GOUACHE

AN ARTIST'S GUIDE TO PAINTING WITH GOUACHE ON THE GO!

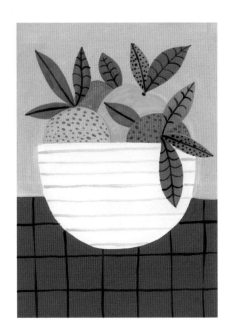

Agathe Singer

Brimming with creative inspiration, how-to projects, and useful information to enrich your everyday life, Quarto Knows is a favorite destination for those pursuing their interests and passions. Visit our site and dig deeper with our books into your area of interest: Quarto Creates, Quarto Cooks, Quarto Homes, Quarto Lives, Quarto Drives, Quarto Explores, Quarto Gifts, or Quarto Kids.

© 2018 Quarto Publishing Group USA Inc.
Artwork and text © 2018 Agathe Singer

First Published in 2018 by Walter Foster Publishing, an imprint of The Quarto Group. 6 Orchard Road, Suite 100, Lake Forest, CA 92630, USA.
T (949) 380-7510 **F** (949) 380-7575 **www.QuartoKnows.com**

Walter Foster Publishing titles are also available at discount for retail, wholesale, promotional, and bulk purchase. For details, contact the Special Sales Manager by email at specialsales@quarto.com or by mail at The Quarto Group, Attn: Special Sales Manager, 401 Second Avenue North, Suite 310, Minneapolis, MN 55401 USA.

ISBN: 978-1-63322-496-4

Digital edition published in 2018
eISBN: 978-1-63322-497-1

Project Editor: Kari Cornell
Page Layout: Krista Joy Johnson

Printed in China
10 9 8 7 6 5 4 3 2

MIX
Paper from
responsible sources
FSC www.fsc.org FSC® C104723

DEDICATION
For Martin and Paula

TABLE OF CONTENTS

INTRODUCTION

Hello, my name is Agathe! I am a freelance illustrator living in Paris. I work for various clients, from perfume manufacturers to fashion designers. Each client provides me with very specific requests or constraints, which guide my work. I also do my own personal projects, where I'm free to choose what and how I'd like to paint. This kind of freedom can be intimidating and sometimes hinders creativity. This is why I like to give myself a framework with which to work: I pick a theme, work on a series with a particular format, or limit myself to a predetermined range of colors.

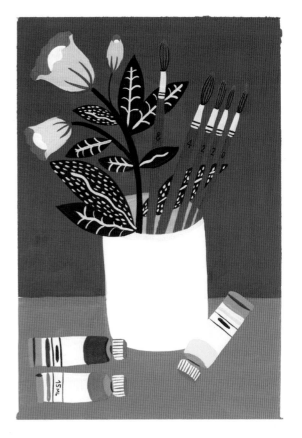

In this book, I will walk you through my creative process, using step-by-step instructions to paint a series of colorful paintings. My hope is that you will learn to love gouache painting as much as I do, and that you will be inspired to develop your own favorite subjects.

WHY GOUACHE?

I love gouache painting for its vivid colors and rich, opaque texture. It is one of the first painting mediums I discovered as a kid, when I worked with gouache in a pan set. Now I work with paint in tubes. The basic process for gouache painting is to take some paint out of the tube, and put it on a palette; you can mix it with water to give it a fluid texture, use it pure, or mix it with another tone to create a new color. The technique can feel a bit overwhelming in the beginning. It takes time to gain a sense of the right texture, to be comfortable using paintbrushes, and to train your hand to work in a fluid motion.

As with any other technique, the best way to learn and improve is through practice! Make it a goal to paint as much as you can. Set easy benchmarks for yourself, such as painting a little motif each day or creating a short series of paintings using familiar subjects.

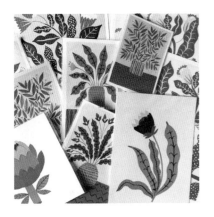

SHARE YOUR WORK

There's no better motivation than showing your work, either in person or online. Regularly posting your work online will encourage you to paint on a routine basis and to interact with others about your work and theirs. At home, treat yourself to frames, and hang your favorite works. This will enhance your paintings and allow you to see them in a different way.

CREATE YOUR OWN SPACE

Encourage yourself to practice painting everyday by dedicating a specific space in your home in which to work and by gathering quality tools that will inspire you to paint. Take the time to discover your own habits and favorite tools, including the time of day that you prefer to work, the pencils you feel most at ease with, and the type of paper that you like best.

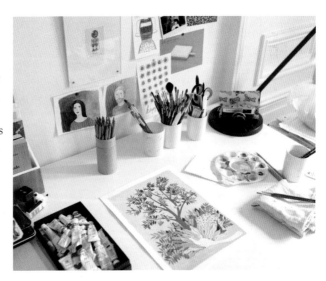

At home, I have a big working desk that faces a wall, but I prefer to paint on my little wooden table by a window—it is barely big enough, but it feels just right. On the table I set a decorated box filled with all my color tubes, a porcelain water jug, my favorite brushes, and paper. I wait until my husband takes our daughter to day care, and then I turn on an audiobook and begin to work.

Keep in mind that reflection is an important part of the painting process, so allow yourself time to ponder the possibilities. When you feel ready, begin to sketch or, if you prefer, jump directly into the piece. I myself like to start from scratch and see where the drawing takes me. Allow yourself to be surprised.

Now, let's get started! Take out your color tubes or blocks, fill up your clean-water jug or dish, and get ready to paint anywhere, anytime!

5

TOOLS & MATERIALS

To create the paintings and projects in this book, I used a wide range of gouache paint tubes, plastic palettes, ceramic plates, and a variety of paintbrushes.

I painted on watercolor paper of various sizes. A pad of watercolor paper is easy to carry, and with the addition of some water, you will find that you can paint anywhere you go.

Gouache paint is similar to watercolor in that the paint is mixed with water before use. Unlike watercolor, gouache is opaque instead of transparent. Gouache dries quickly, but you can always add more water and continue to work.

PAN SETS

These might remind you of your childhood. When I started to paint again with gouache, I bought a box of kids' paints to revive the joy of those simple colors. The pan is easy to transport and use, though the texture is thinner and the colors less vivid than the ones sold in tubes.

TUBES

My favorite paints are those sold in tubes. In addition to basic tones, you will find a wide range of beautiful colors. Some brands offer as many as ten different tones of blue or red alone. The texture can vary considerably based on the quality of the gouache. Try different brands and quality ranges to see what suits you the best.

PAINTBRUSHES

Paintbrushes can be made from natural
animal (squirrel, pony, badger) or synthetic
hair, which is cheaper and easier to wash.
Each material has a different touch and
flexibility. I love to use a variety of very thin,
firm brushes for details, and two or three
larger, softer brushes for backgrounds.

PALETTE

I mix my color on ceramic plates or reusable
plastic palettes. Ceramic plates are easy to
wash but heavier to carry around, whereas
reusable plastic palettes are lighter and very
practical.

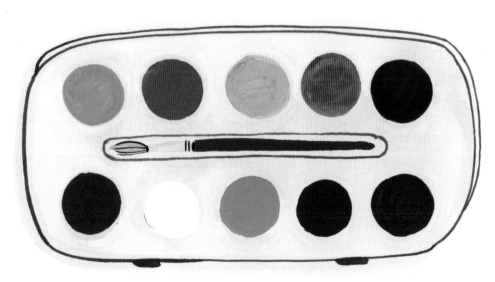

PAPER

You can paint on various papers, but don't forget that gouache is a water-based medium. If you use a paper that is too thin, it will warp when water is added. I usually use a 300 gsm hot-pressed watercolor paper with a smooth texture. You can also paint on paper with a thin or rough grain. Although it is harder to paint very thin details on a rough-textured paper, the texture does bring an interesting and raw quality to a painting.

PAPER BLOCKS & SKETCHBOOK

I usually work with several paper blocks at the same time; it allows me to work on a new project while another one dries. I also keep sketchbooks on the side to try new color swatches or sketch an idea.

OTHER TOOLS

Masking Tape

I use paper tape to protect the edges of the paper when I paint a colored background. Choose a thin or wide tape to create a nice white frame around your painting.

Colored Pencils

You can use a pencil to sketch before you paint. Make sure to use a color that is light enough to be covered by your paint.

Hair Dryer

If you are impatient like me, you can use a blow dryer to speed up the paint-drying process. The dryer quickly dries the paint, allowing you to work over it without any surprises.

Glazing

Gouache is a water medium, so it will be vulnerable to water until you varnish it. You will find matte, satin, and gloss-finished varnishes, and all work well, depending on the finish you desire. You can also protect each painting from water by storing it in a thin, plastic envelope.

Gouache tends to dry in a lighter tone than when it is applied, making it difficult to reproduce an accurate color swatch. If you are working on a large colored area, be sure to mix enough color to cover the entire surface. Mixing a new batch of paint halfway through may result in noticeable color variations.

PAINTING & DRAWING TECHNIQUES

After years of working mostly with watercolor paint, I recently began using gouache. As I mentioned earlier, the main difference between watercolor and gouache is in the results: Watercolor is very light and transparent, while gouache is dense and opaque.

When I first began to experiment with gouache, I bought a few tubes to try out the medium. What a disaster it was! I wasn't at all used to the texture and the thickness of the paint, nor did I understand the proper amount of water needed to mix the colors, which were always too liquidy or too pasty. I was very close to giving up, as my paintings had become heavy, awkward, and full of lumps.

But the brightness of the colors pushed me to keep trying. Gouache paints are so strong and vivid, and I loved the fact that I could paint over a color swatch with lighter tones, such as adding stars on a dark sky or white flowers on a deep green background. This simply can't be done with watercolors.

I kept trying, and now gouache has become my favorite medium. I hope that with some patience and experimentation, you will like it as much as I do. Don't worry if your first paintings are a bit messy; with a bit of practice, you'll soon get used to the idiosyncrasies of the medium.

Here are some tips I learned along the way. Let's give it a try!

keep all your paintings;
they are a journal of
your artistic journey.

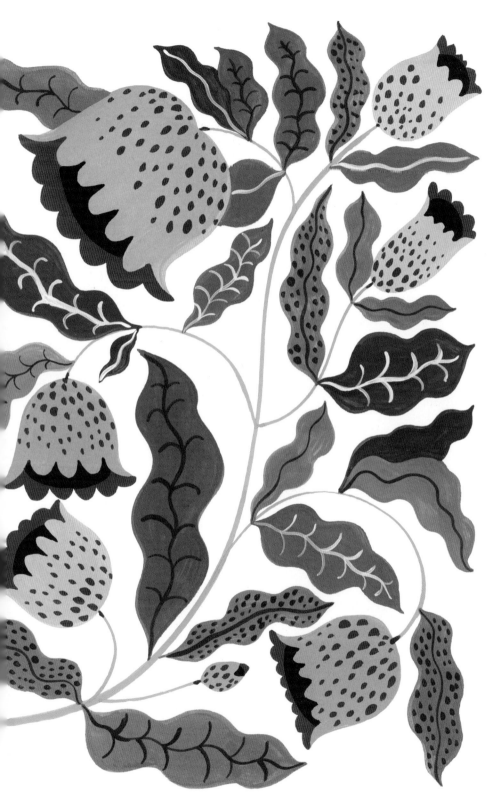

11

WATER

The first challenge with gouache paint is finding the perfect balance of paint and water. Use a porcelain plate or a plastic palette to prepare your color. Dab a small amount of paint on the palette, and use a paintbrush to get a sense of its texture. That texture will differ from one brand of paint to another: some are extremely thick—even hard—while others are so fluid and soft that you almost can use them directly from the tube without adding water. If you feel the color doesn't flow easily with your brush, add a little water. I personally like a more fluid texture when I paint precise shapes, such as those in a flowery pattern, but I prefer a thicker texture that's more lively for sketching an object.

Pick a color and experiment by mixing it with more or less water; observe the subtleties of tone and texture.

12

TO SKETCH OR NOT TO SKETCH

If you like to sketch your subject before you paint, pick a light colored pencil to draw a design on your paper. The paint will cover it completely so you won't see any trace of it. However, I like to paint without sketching first. Sometimes I even begin painting without an idea of what I'm going to do next. I like to see what happens when I don't plan ahead.

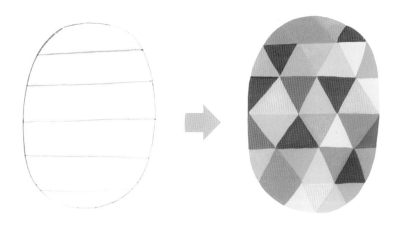

Try working without sketching and allow yourself to be surprised by the painting!

RETOUCHING

You can retouch a gouache painting, even after it has completely dried. Simply remix the color on paper using clean water, and then absorb it with a paper towel. Let it dry, and paint again. You can also paint directly over the first layer, which will add relief and thickness to your painting.

LAYERING & TEXTURE

Gouache is usually very opaque, so you can superimpose many layers of color over each other. If the first layer is not completely dry, the layers will mix, which can be a bit messy but interesting. If you prefer to keep the painting neat, only add layers over paint that is completely dry. Consider adding contrast and precise details to a color swatch.

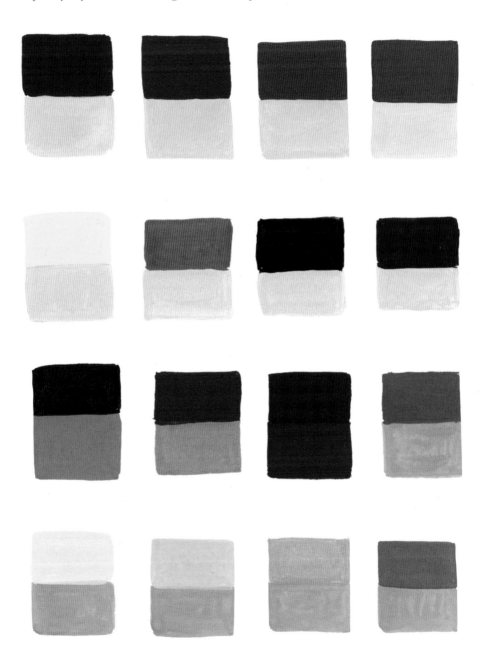

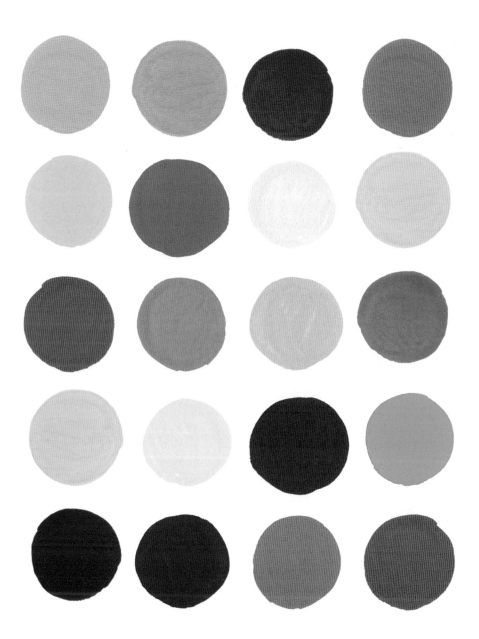

Experiment with texture by painting enough circles or squares
in a wide range of colors to cover an entire page. The practice of
filling the many swatches of color will help you develop confidence.

PAINTING WITH A BACKGROUND

You can paint a subject on blank paper or on a background. There are three ways to paint a subject with a background. The first one is to begin by painting the color of your background, leaving the area blank where you will add the subject later. The second option is to paint your subject, and then add the color of the background later. I like the third option best, which is to start with a full background of color. I love to see a pink, green, or blue paper and think about what I should paint over it. Beware: With this third method, the background paint must be dry before you paint over it; otherwise, the colors will mix.

I like to use masking tape to protect the edges of my paper before painting a background. When the painting is dry, I peel away the tape, leaving a nice white frame around the painting.

DOTS, LINES, STROKES, AND WAVES

I like to finish a painting by adding lots of detail, including those little elements that add charm to the painting—a pattern in the background, crosshatching on the skin of a fruit, little lines to shape the veins of a leaf, individual hairs on a cat's coat. I keep a variety of brushes on my worktable. Using brushes of different shapes and sizes provides interesting line variation in a painting.

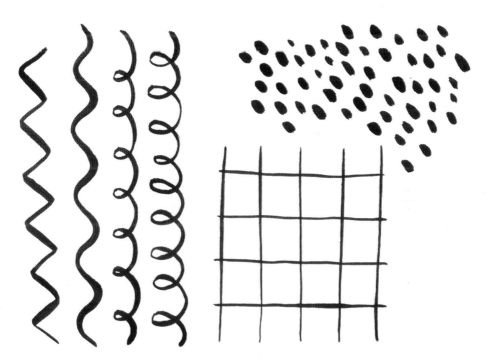

Try to paint lines using a variety of brushes, from very thin to very large. Then experiment with other patterns. Some brushes, for example, have a round point that's perfect for painting dots. Others are very supple, making them just right for painting waves and zigzag patterns, as they will vary from a thin to a thick line. Try crosshatching, or crossing lines over each other. Eventually, the manner in which you use brushes to paint will become part of your artistic language.

Develop your own toolbox of go-to designs. By creating favorite patterns and details that are uniquely yours, you can add your own personal touch to each painting.

COLOR THEORY

When I first went back to illustration and painting, some years after art school, I had a big color block. I didn't trust or believe in my own taste. While painting, I was always thinking, "Do these colors fit together? Is it tasteful? Isn't orange and pink a forbidden match?" and so on. I worked in black and white at first, with a bit of blue at best. What sadness! It took me months before I was able to slowly allow myself to play with colors.

I hope you won't make the same mistake and are able to jump without fear into the beautiful range of colors that gouache paint offers. The best advice I can give is to trust the fun you're having while painting. Do you like that bright ultramarine blue (my favorite!) or that bold and eccentric purple rose? Then use them—a lot! Try to match them with other colors.

In addition to some basics in color theory, this chapter will give you tips on how to find your own color language.

Color is not about good taste; it's about experimenting and creating emotion.

COLOR BASICS

Primary colors can be mixed to create secondary colors: blue and yellow make green; blue and red make violet; red and yellow make orange. Gouache paint comes in a very large range of colors: primary, secondary, and a multitude of others created from various pigments, such as burnt earth, cobalt, and zinc. White paint is the most luminous of all. Even though it is supposed to be colorless, you will find various whites from slightly blue to slightly yellow. On the opposite end of the color spectrum, black reflects almost no light. Black and white paint are usually sold in larger tubes. Use them to create variations in tone, from lighter to darker.

Beware: Most pigments are toxic. Do not put a paintbrush in your mouth or allow children to play with the colors.

USING PURE COLORS OUT OF THE TUBE

Some colors are not my taste and I always mix them to create new tones. I find others so extraordinary and peculiar that I almost never mix them with another. Ultramarine blue, geranium lake, Naples yellow … even their names inspire me! You will find that some of your favorite colors come straight out of a tube.

When you have to paint a large surface, it is sometimes easier to stick to a pure color, as it can be difficult to recreate a color mix from a swatch of paint that has already dried. As gouache paint dries, it lightens a bit, so a dried swatch of color is never a reliable reference.

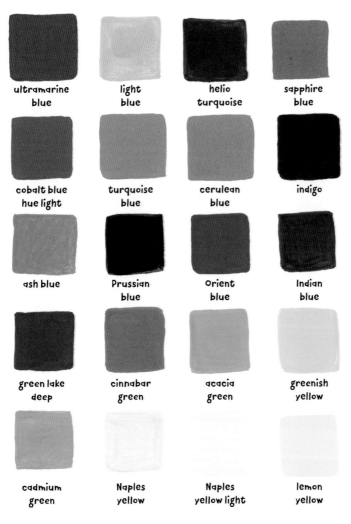

ultramarine blue	light blue	helio turquoise	sapphire blue
cobalt blue hue light	turquoise blue	cerulean blue	indigo
ash blue	Prussian blue	Orient blue	Indian blue
green lake deep	cinnabar green	acacia green	greenish yellow
cadmium green	Naples yellow	Naples yellow light	lemon yellow

Create your own color chart. Take a bit of color from each of your gouache tubes, and apply it to a sheet of paper, adding the name of the tone under it. Keep this chart with you at all times; it will help you pick your tones.

MIXING COLORS

Although gouache paints come in vast range of colors and tones, you'll want to try to make your own mix of colors. When I create a color of my own, I start by picking the color that is the closest to the final result I'm after. For example, if I want a pale pink, first I'll put some white paint on my palette. Then I'll add a very small amount of a vivid pink. Gouache pigments are so rich that you need very little paint to drastically change the color. You can create a smooth blend and perfectly unified new tone, or leave the colors a bit unmixed for more texture. I would recommend mixing no more than two colors at a time; otherwise, you'll find yourself with an unattractive brown.

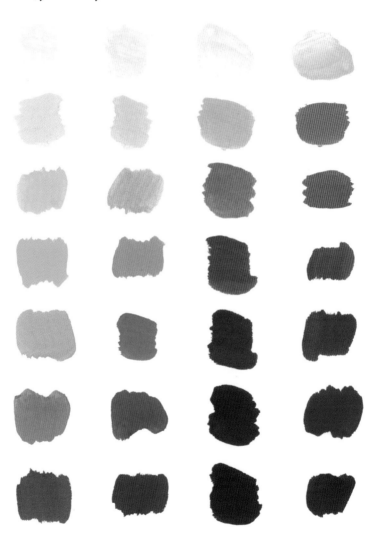

keep your paintbrush clean, and be sure to change
your water often. You don't want to see an
unexpected tone creep into a blend as you mix.

22

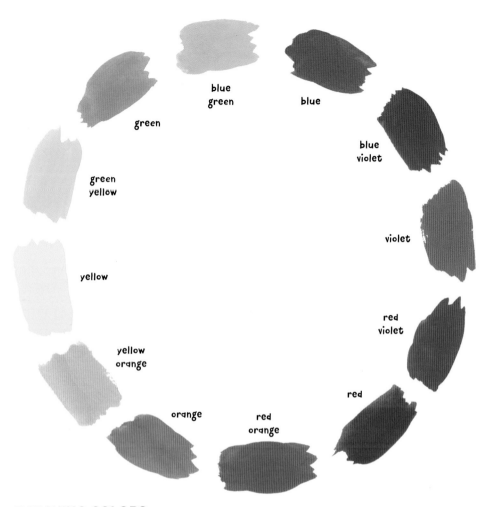

blue
green

blue

green

blue
violet

green
yellow

violet

yellow

red
violet

yellow
orange

red

orange

red
orange

MATCHING COLORS

Complementary Colors

On a color wheel, complementary colors are two colors that sit on opposite sides of the wheel. For example: green and red, blue and orange, and yellow and violet. Complementary colors enhance each other.

Shades

You can work with shades of the same color, from lighter to darker. Those nuances look better when used with another contrasting color.

Warm & Cool Tones

Some tones, such as brown, red, pink, orange, and yellow, will give a warm feeling to a painting. Other tones, such as gray, purple, blue, and green, are cool and will give a fresh tone to a painting. Try using warm tones with cool tones for unexpected results. For example, I like to use mostly cool tones, like a green plant on a blue background, and add some very warm touches of paint, like bright pink flowers, for a fun twist.

23

Color Block

I'm not afraid to create eye-catching color matches. I love to paint a bright yellow lemon on a vivid pink tablecloth with a blue background. But, since the eye needs some respite from the bright, contrasting colors, I like to leave a large piece of white in the painting: the porcelain bowl in which the lemon sits, for example.

Mix and Match

I don't think any color theory teaches you about your own color match preferences. That comes with practice. One good exercise is to paint little swatches of the same color, side by side, and match them with different tones. Do they work better in bold contrast with another strong tone? Do they look better paired with a lighter, duller tone?

Black and White

Light and shadow will give depth and relief to your painting. Lighter tones look as if they pop forward from the page, while darker colors seem to recede into the page. When used in their pure form, black and white paint creates interesting contrast and effects of light and reflection.

FAMILIARIZE YOURSELF WITH COLORS

Maybe you're like me and you bought too many tones from the start and now can't decide which colors to use. Or, you didn't take any risks at first, and bought very few tones.

One option is to begin to work with just a few colors. Let's pick three tones. I myself love the combination of a vivid blue, a bright pink, and a yellow. Try to create a series of paintings using only those three colors. See how the individual colors stand out differently when used on the background versus in the motif, on large swatches, or on details. Mix them together to add other tones. Add white to create new shades from the original three colors, and use them to enrich your painting.

CREATE YOUR OWN LANGUAGE OF COLOR

Taking the time to experiment with colors is important, as you will progress and learn which colors and matches feel right to you. You will create your own language of color, which will make your painting personal and your style easily recognizable.

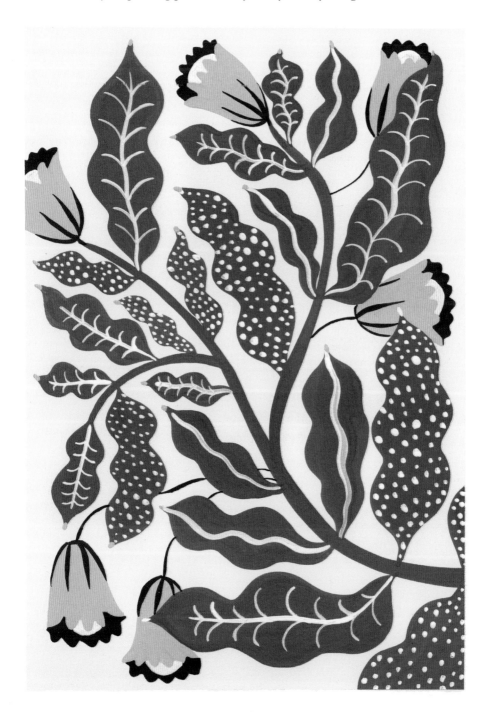

PAINTING ON THE GO

With the right materials, a little imagination, and a bit of practice, you'll see that you are able to paint beautiful gouache paintings anywhere and at any time. In this chapter, you'll find everything you need to know to make painting a joyful and fun part of your everyday life, including the best supplies to carry with you, how to always have enough water on hand, and tips for how to find inspiration all around you. Then we'll take it to the next level and begin to create beautiful paintings together, following step-by-step projects and short exercises. Let's go!

PAINTING ANYWHERE

I've been self-employed for some years now, and one of the things I appreciate the most is the freedom to work anywhere I want. I work on the big desk or the small table in my office, in a café in Paris, in my in-laws' living room in Austria, at my parents' house on the west coast of France, on any camping table during a road trip, on the beach, and so on. I have even worked on my bed or couch when I was expecting my baby.

I wouldn't say that I'm to the point where I can casually take out my gouache, let's say in the subway, and start painting. Although I always do carry a small notebook and some pencils in my bag to sketch or write down ideas, painting even a fast sketch demands a bit more preparation, as the technique requires water and a place to sit still for a moment.

Over time and with practice, I have culled and curated the tools and materials I keep in my painting bag. Here are some tips that I learned along the way.

**Learn to make gouache
painting a fun, joyful part
of your everyday life!**

26

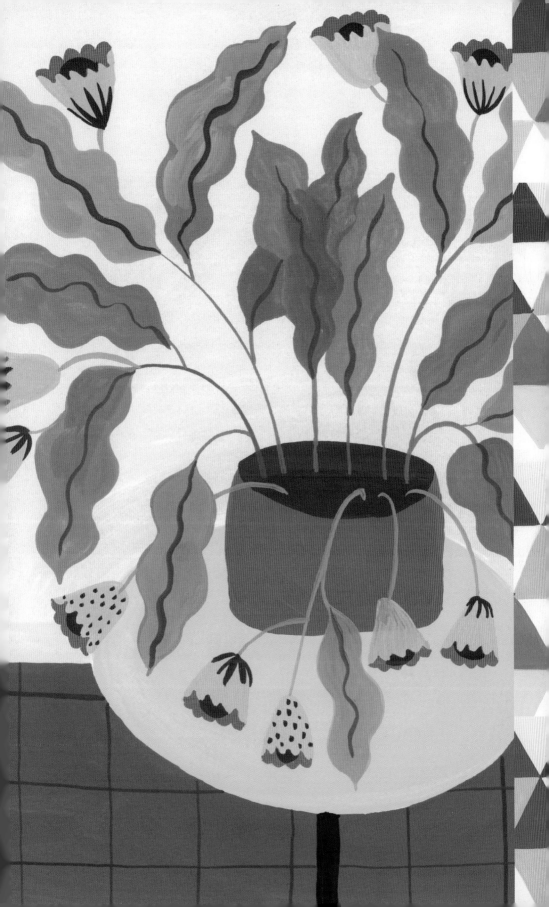

PACKING YOUR BAG

Back when I was an art student, my painting bag was the worst mess you ever did see, full of crumpled papers, leaking paint tubes, and damaged paintings and drawings. With time, I learned how important it is to take good care of my materials and work, which has saved me money, time, and many regrets.

Now I carry around a very organized bag. I pack a waterproof toiletry case with paint tubes, so I don't have to worry about leaking paint seeping through the bag. I keep the paintbrush in a separate box so the bristles don't get smashed. I also carry a foldable water pot with a little bottle of water, which, more often than not, I forget. When I find myself without water, I improvise—I've painted with water from a fountain, a lake, the sea, and even from a glass of light grenadine. I always take paper in blocks with a hard cover, so I can use it as a support. I also bring along a plastic sleeve to protect the finished paintings.

To lighten your load, try packing a smaller block of paper, your favorite paintbrush, and only a few colors. As you can see, you can create a beautiful painting using only three or four different tubes of paint.

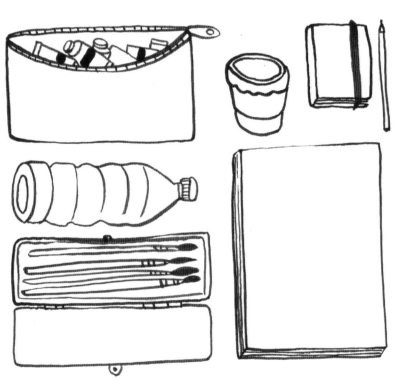

FINDING INSPIRATION EVERYWHERE

Nature is one of my main sources of inspiration. If, like me, you don't have a garden or live in a beautiful countryside, you can always find inspiration on the go, simply by walking around your town. In Paris, I love to wander around the flower market and the Jardin des plantes with its botanical garden, menagerie, and beautiful glasshouse full of exotic plants. You will find that plants provide a wealth of beautiful motifs, colors, and details for your work. Even a single pot of geraniums on a windowsill, with its bright contrast of vivid reds and greens, can make a terrific subject for a painting.

I also find myself in parks a lot now that my toddler is walking. I watch as she sits on the ground and looks passionately at a blade of grass or a piece of wood. I can't wait until she is big enough to help me collect plants for our own herbarium.

In a park or within view of your window, look for flowers to paint. Try to paint them the way you see them, not the way they are.

SKETCHING ON THE GO

When I don't have the time to paint or sketch something I see, I love to take pictures with my phone or digital camera to use later as inspiration. I also love to collect guidebooks about birds, mushrooms, or exotic flowers. In my paintings, I love to mix in something that I saw on the go or an exotic animal or plant that I'll maybe never encounter otherwise. More often than not, I let my imagination overrule reality in my work. Unless you are a meticulous botanical painter, you will find that the more you develop your own personal style and painting language, the more you will interpret the things you see and turn them into a fantastical visual world that is all your own.

A 365 DAYS PROJECT

The best way to make progress when learning a new painting technique is to get into a habit of practicing a little bit every day. Try to find a quiet moment for yourself, and dedicate that time to painting. Depending on the amount of time or the level of energy I have, I may paint a full subject over several days. Other times, I only sketch or try out a new color of paint.

I have favorite subjects, like flowers and birds, which I like to paint more than anything else. Both are recurrent themes in my work and crop up as a pattern in most of my paintings. I always feel at ease when I paint flowers and birds, which gives me the freedom to experiment with new colors and composition in the spaces around them.

There are other subjects, like portraits, that I'm not very comfortable with. I try to set aside moments to practice those not-so-easy subjects by giving myself small goals. For example, the other day I painted a little series of ladies with cats. I'm always uneasy when I try to paint realistic characters, so this time I decided to paint the ladies the way I paint my flowers: using simple shapes and contrasting colors.

With practice and time, you will discover your own favorite patterns and subjects—and those not-so-favorite subjects that you need to work at improving. If you feel stuck at any point, don't give up. Instead, set it aside and come back to it later, maybe working on it from another angle.

Try filling a small sketchbook with drawings or paintings
of a subject you aren't comfortable with, or do a series
of little painted variations around the same motif.

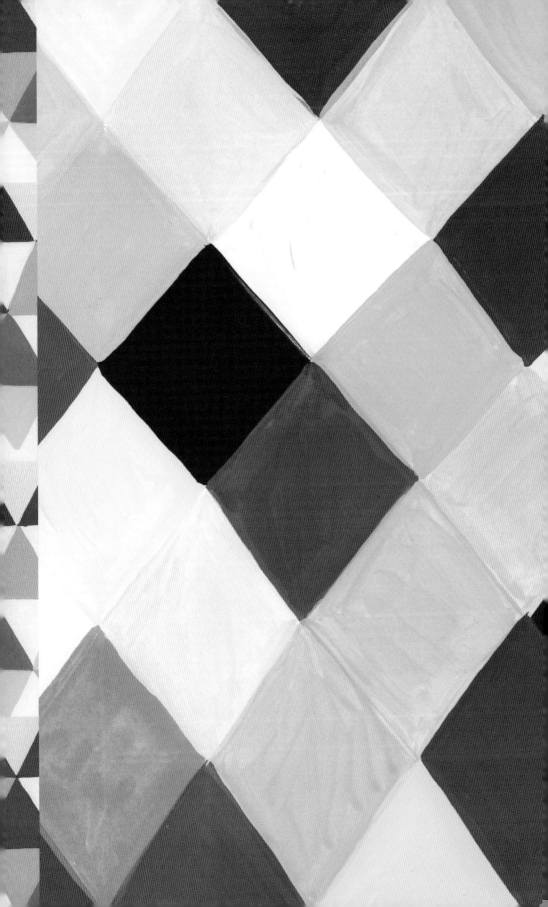

PROJECT 1
HARLEQUIN PATTERN

I find painting patterns to be very relaxing, and it's a great way to practice when you don't have a subject in mind. When I find myself a bit tired, down, or with a case of painter's block, I just paint a series of abstract and geometric patterns. Repeating a pattern without thinking about a subject clears the mind, allowing me to enjoy painting and playing with colors.

I love painting a harlequin motif, which is a repeating pattern made of diamond shapes. I usually split those diamonds into triangles. You can repeat the pattern as long as you want or enclose it within another shape.

We will paint this motif freehand, so no ruler is needed! This exercise will train your hand to be firm and steady, but the charm of this painting will also be in the little variations and imperfections in the shapes of your triangles.

Painting patterns allows you to experiment with colors you've never tried before, see how they work together, and observe how certain combinations will change the tone of your painting.

PAINTING A GEOMETRIC MOTIF

Now, let's begin with a colorful triangle motif.

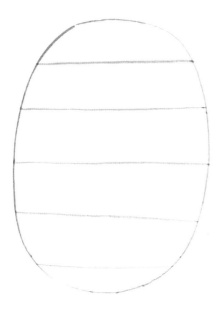

STEP 1

First, draw an oval shape to enclose the pattern.

On a separate piece of paper, take a moment to practice drawing circles, ovals, and lines with a steady hand.

STEP 2

Divide the oval shape using lines, which will become the bases of the triangles.

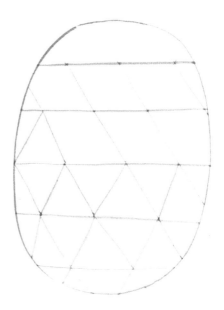

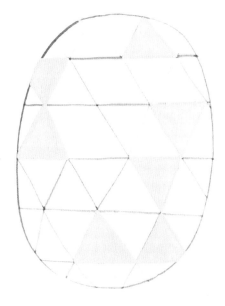

STEP 3

Start to fill triangles with shades of blue, beginning with a pale tone and working toward a very bright, strong blue.

STEP 4

To contrast the blue nuances, I select a few pastel tones and fill more triangles. Feel free to experiment with color blocks and create new color swatch matches.

Starting with lighter tones allows you to paint over anything you don't like with a darker color.

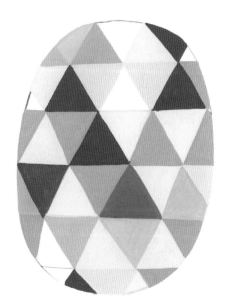

STEP 5

Our pattern is almost finished! I complete it with very dark triangles to add contrast.

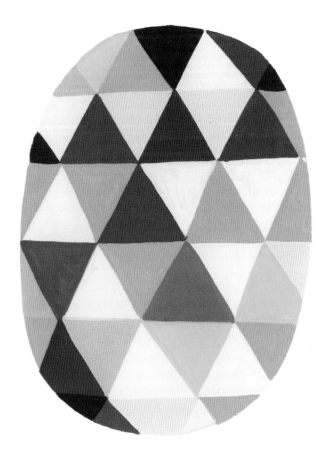

When using black, mix it with another color like blue or red. This will give depth and nuance to your darker tones.

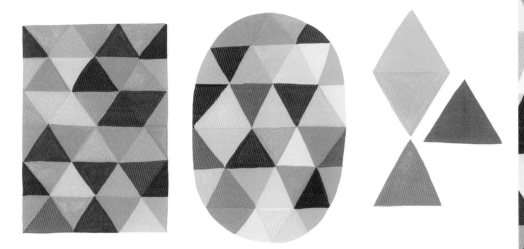

USING PATTERNS

Geometric patterns are very useful, as they can be included in many other subjects you like to paint. For example, a geometric pattern can be used to decorate an entire wall in an interior room, as a motif for clothes in a portrait, or as an abstract background for a flower painting. If I paint a table with a vase full of flowers, I love to add a pattern to the tablecloth and paint a motif on the vase. It creates a joyful effect as the colors contrast and play with each other. When it comes to patterns, I love to mix and match!

Now that you've mastered triangle motifs, you can practice on other geometric patterns. Try waves, circles, squares, or any other shape you can think of.

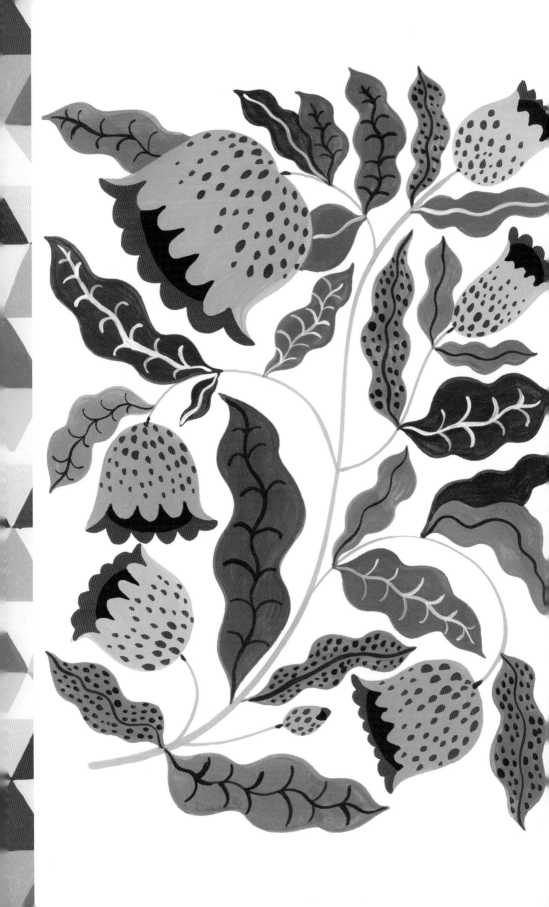

PROJECT 2
FLOWER

Flowers are one of my favorite subjects. When I was seven years old, my family moved from a flat in the city to a house in the countryside with a huge, wild garden full of trees and flowers. I remember that the peonies were just blooming, creating an extraordinary explosion of red and pink petals. Now that I live in Paris, there is no greater pleasure for me than to bring home an armful of fresh blooms from the flower market.

Flowers are a wonderful subject for a painting, whether you take inspiration from nature or your own imagination.

I'm very lucky to work with Fragonard, a French perfume maker. Every year they pick an iconic flower for a perfume range, and I illustrate the packaging with paintings of the blooms. From jasmine to irises, peonies or sweet peas, this experience has taught me that each flower has its own meanings, symbols, and history.

The idea of a flower is very simple: a stem supporting the head with petals and maybe a few leaves. From that base you can experiment with the shape, size, and colors of the petals, add the details of the pistil and stamen, and play with motifs on the leaves.

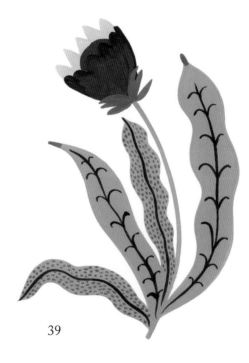

PAINTING A SIMPLE FLOWER

For now, let's start with a single orange flower.

STEP 1

Paint a thin, curved green line for the stem and the orange outline of the corolla. For the corolla, paint an oval shape, making it more pointed on the bottom where it connects to the stem. At the top, add a scalloped edge for the tops of the petals.

STEP 2

Using a bright orange tone, fill the corolla with color. Paint three leaves along the stem. I give them each a wavy shape, beginning with a wider base where the leaf touches the stem and tapering to a pointed tip.

Try to play with the shape of the leaves, making them round or pointy, curvy or thin.

40

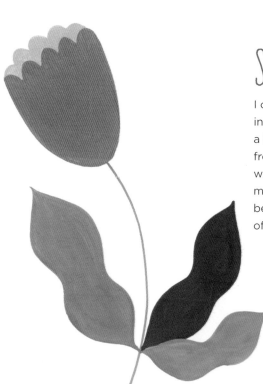

STEP 3

I choose a light pink color to paint the inside of the corolla. This step gives a bit of depth to the flower. Starting from the top left of the corolla and working right, add a row of half-moon shapes, and then fill the space between the half moons and the top of the corolla with color.

STEP 4

Using a dark green tone, paint wavy lines in the middle of each leaf, and add shorter lines to shape the veins.

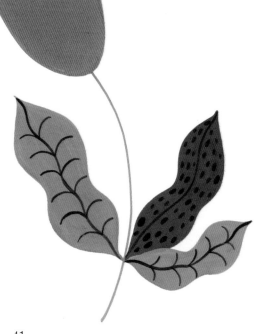

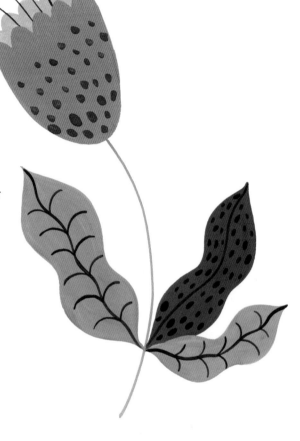

STEP 5

To finish, I embellish the corolla with red dots and add thin lines with dots for the stamen and pistils.

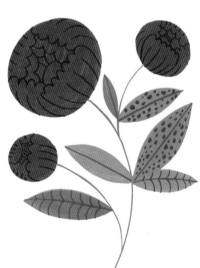

From this first single flower, try adding a branch from the main stem and drawing another corolla or a flower bud.

AN ABUNDANT SUBJECT

From Henri Matisse to Georgia O'Keeffe and Alex Katz, many great artists have placed flowers at the center of their paintings. Flowers are a beautiful still-life subject, whether you paint a single bloom or a bouquet. Flowers are also a great addition to other scenes; you can place flowers in the hand of a subject featured in a portrait or add a bouquet to an indoor scene.

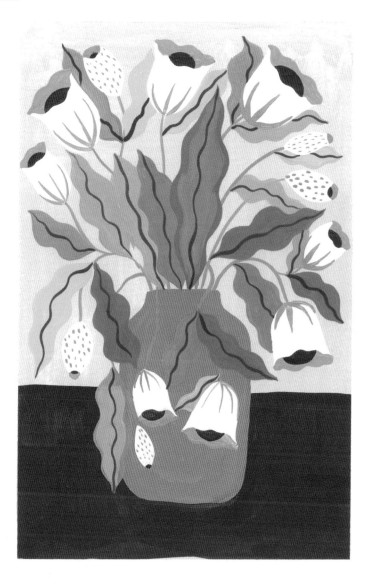

Turn your single flower illustration into a bouquet by adding several other flowers to the bunch. Begin your bouquet painting the same way you did the single flower: first the stems and then the petals and leaves, finishing with the details and embellishments.

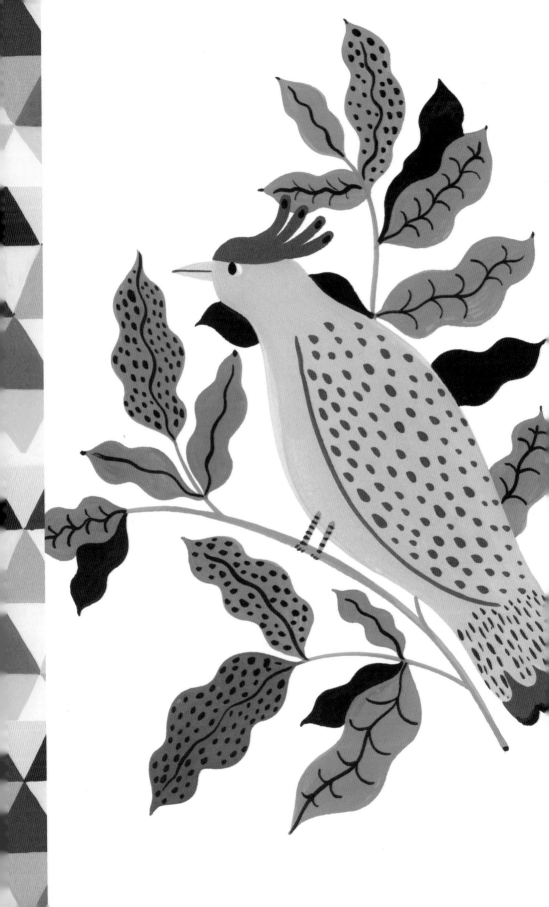

PROJECT 3
BIRD

I love birds; they are delicate, lovely, and mysterious creatures. As a kid, I liked making little birdhouses in my parents' garden and watching the chickadees and robins nest. I even joined an ornithological club in junior high. We used to wake up at dawn and spend hours watching and drawing migratory birds nesting for the summer or on their way to Africa for wintertime. Because I love birds so much, they've become a recurrent motif in my paintings. I live in a city now, so when I tire of painting gray pigeons, I paint other species from my imagination or with the help of a bird guide.

You'd be surprised how easy painting a bird can be. From one simple shape, we can create a joyful bird. Here's how.

PAINTING A BIRD MOTIF

Let's paint a blue bird with a white pattern and a red tail.

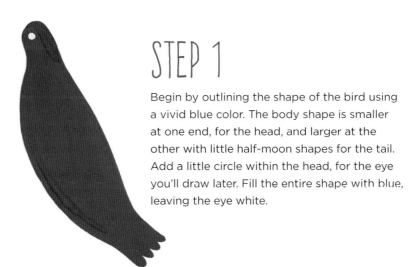

STEP 1

Begin by outlining the shape of the bird using a vivid blue color. The body shape is smaller at one end, for the head, and larger at the other with little half-moon shapes for the tail. Add a little circle within the head, for the eye you'll draw later. Fill the entire shape with blue, leaving the eye white.

STEP 2

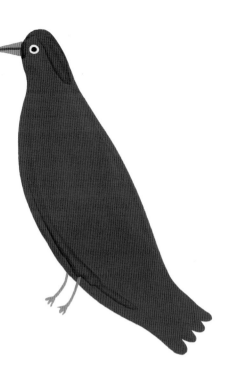

With a light coral color, paint a triangular shape for the beak and two little legs. With blue, draw a thin line to create the split in the beak, and add a dot to the center of the eye.

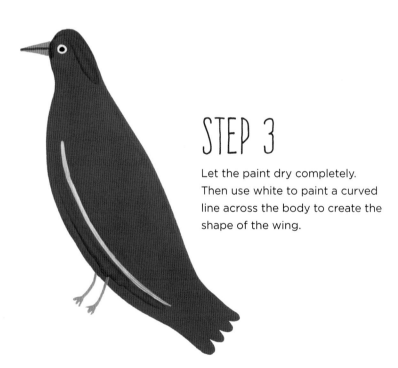

STEP 3

Let the paint dry completely. Then use white to paint a curved line across the body to create the shape of the wing.

STEP 4

Select a bright red color to paint a second tail under the first, using the same half-moon shapes as for the first tail.

STEP 5

Our bird is almost finished! Let's add some little details that will make it very special—a few white dots on the wing and some curly feathers on the head. Voilà!

The charm of this bird is in the details. Use dots, lines, a shell pattern, and crosshatching to embellish the plumage.

A LIVELY MOTIF

Birds are fun to paint as a main subject or as inhabitants of a nature scene. When you are painting a garden, try adding little birds in the branches. They can be as mysterious as a white owl, spooky as a black crow, magnificent as a peacock, or joyful as a parakeet. Whether you are painting from nature or not, birds promise to be a subject with endless possibilities for your imagination and full of colors, details, and patterns.

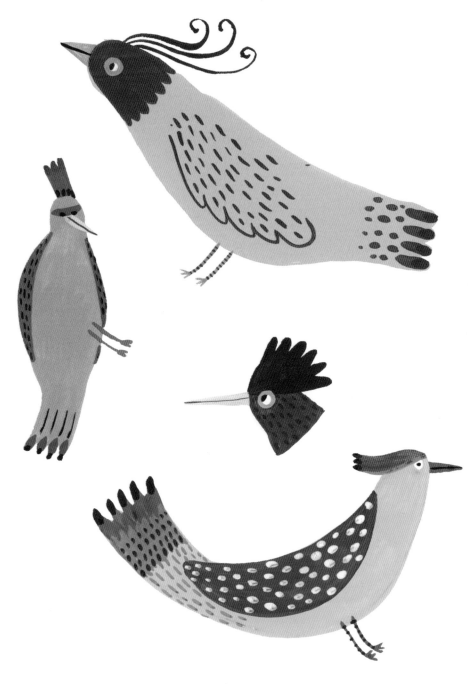

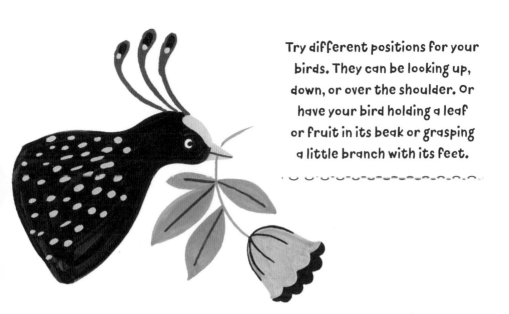

Try different positions for your birds. They can be looking up, down, or over the shoulder. Or have your bird holding a leaf or fruit in its beak or grasping a little branch with its feet.

Now that you feel confident drawing a motionless bird, try to open its wings! Flying birds are great; they give you a bigger surface on which to decorate and embellish.

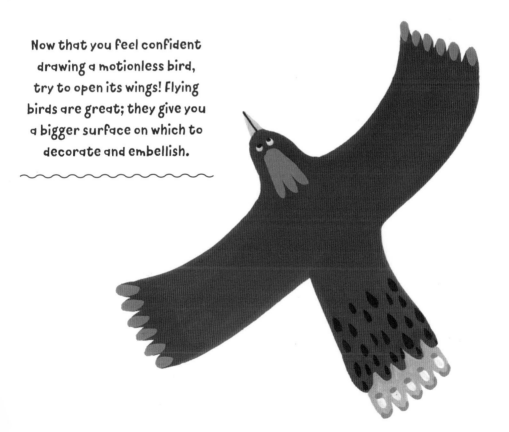

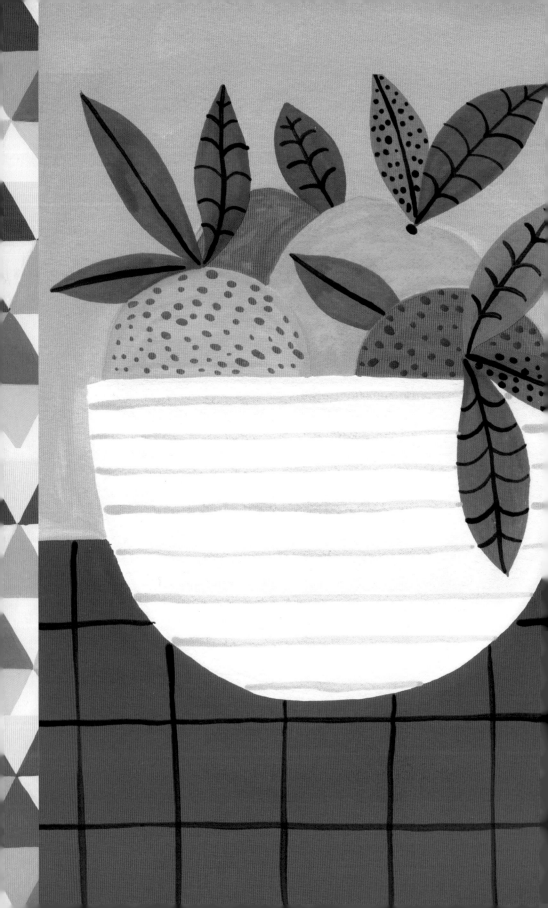

PROJECT 4
FRUIT

When my baby is falling asleep at night and I must be very quiet, I set my painting desk in the kitchen where she can't hear the clattering of paintbrushes and tubes. The kitchen is a great room for inspiration. You will always find colorful subjects to paint whether it's the fruit basket, herbs in a pot, or the boxes, bottles, and food packages stacked on the shelves. Painting the labels can be a good lettering exercise. Then you have the bowls, glasses, water or wine jugs; the teapot; the coffeemaker; and the tablecloth and napkins, which are full of motifs.

Let's start with the fruit basket. We'll pick an orange with its leaves still attached.

PAINTING ORANGES

Let's paint a few oranges with leaves.

STEP 1

Begin with the shapes of the oranges. It's not that easy to paint a circle in one steady gesture. First use a pencil to train yourself to draw dozens of circles; then try with the paintbrush. It's easier when the gouache is very wet, as the brush will slide better on the paper.

STEP 2

Fill the round shapes with the same orange color. Later, when the color is dry, you'll add details on the skins of the fruit.

STEP 3

I paint one dark leaf and three lighter ones. You are already familiar with leaves from our flower paintings—the leaves of an orange are thin, pointy, and deep green in color.

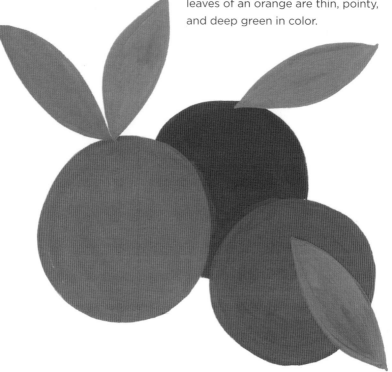

STEP 4

Using a darker orange tone, add tiny dots on the oranges to evoke the texture of the peel. Finish by painting the details of the leaves' veins, using a dark tone to contrast with the green.

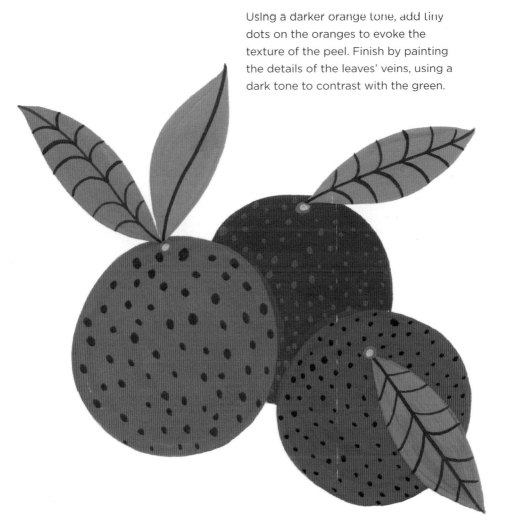

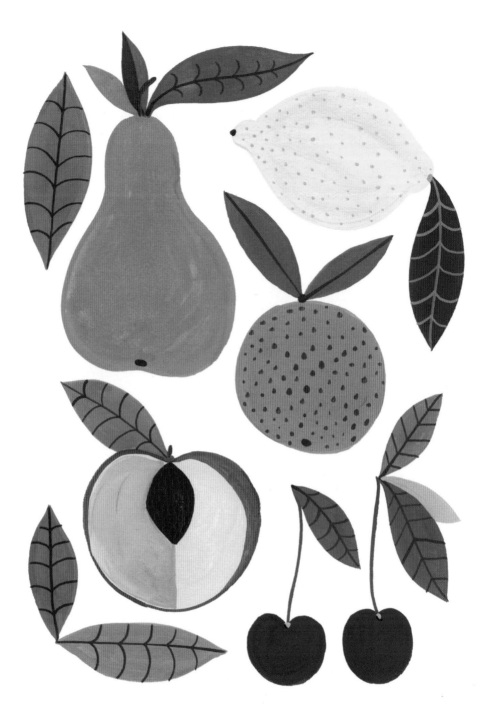

Many fruits are as simple to paint as oranges. Now
try to paint a bunch of apples, peaches, or lemons.

Try to fill a page with myriad fruits and
leaves to create a joyful pattern!

FRUITFUL FUN

A basket or a bowl of fruit is a great subject, as you can have fun drawing the fruit and also adding interesting details and patterns to the bowl or the tablecloth on which it's placed. You can work on color composition, playing, for example, with the contrast between the colorful fruits, the white porcelain bowl, and a dark table. Your fruit can be neatly placed in a basket or scattered around the table.

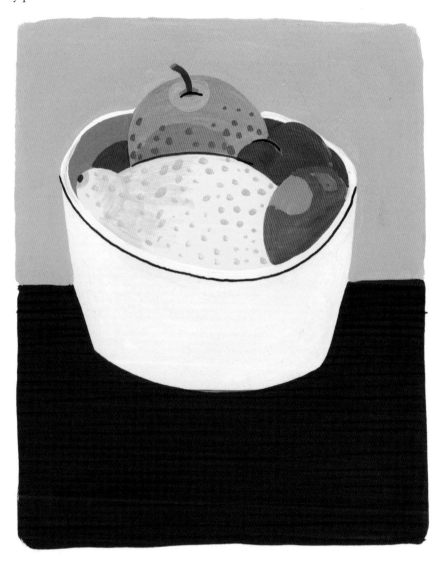

Try cutting open a fruit, such as a white peach. You'll find that the beautiful contrast between the coral-pink color of the skin, the pale pulp, and the darker pit makes for an interesting composition.

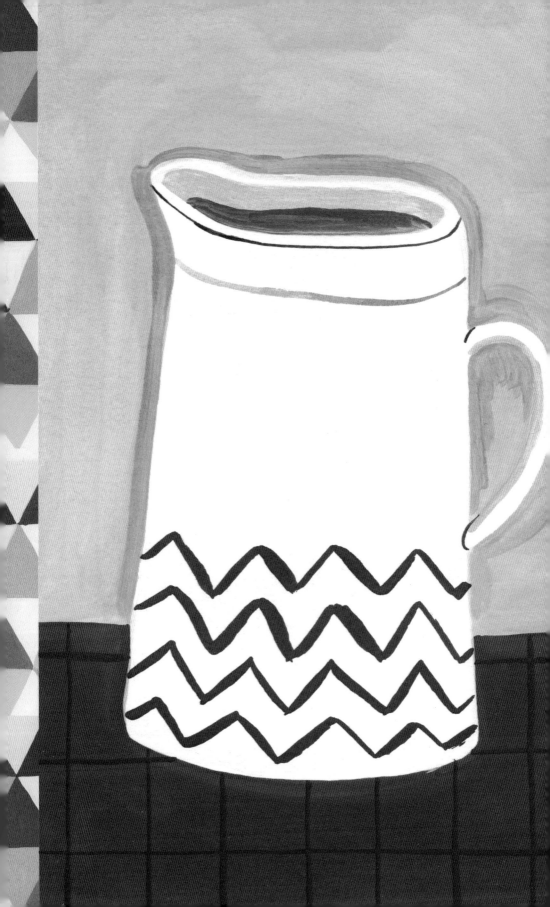

PROJECT 5
FAMILIAR OBJECT

Wherever you are, you can always find an interesting subject to paint using the objects around you. Some objects are easy because they are special, colorful, or full of patterns. Others won't seem interesting or meaningful to you, but if you take a closer look, you will find that every single object can be made into a good painting. Look at the tools you use to draw, the books or personal items on your bedside table, knickknacks in a box full of souvenirs, boxes of food on top of your fridge, or a clock at the post office—the possibilities are endless.

I don't think you have to try to be realistic. The object can be the center point from which you imagine and create a colorful scene. Play with the colors and with the background. Your object can be hanging on striped wallpaper or placed on a black-and-white tile countertop or flowery tablecloth.

For this project, I selected a ceramic water jug that I'll paint in front of a two-color background with tiles.

When you paint with a background, you'll need to allow the paint to dry, so the subject and the color around it don't mix. If you have a blow dryer handy, this is a good time to use it!

PAINTING A PITCHER

I'd like this painting to have a colored background, so I start by protecting the edge of my paper with masking tape. I'll remove it once the painting is dried and finished, revealing a white frame around the image.

STEP 1

Start with the shape of the jug, which is a bit larger at the base with a little spout on the top. Add an arc shape for the handle.

STEP 2

Fill in the entire pitcher with a light pinkish color.

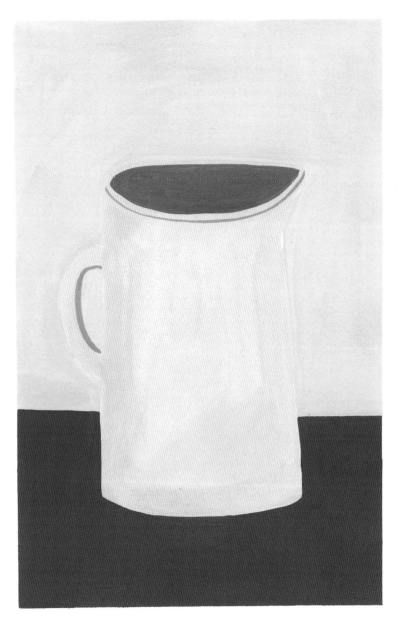

STEP 3

When the paint has dried completely, draw a line to separate the background into two parts. I fill the background above the line with light blue and below with a darker tone. To give volume and depth to the pot, paint the inside of the jug a dark gray and add a shadow under the handle.

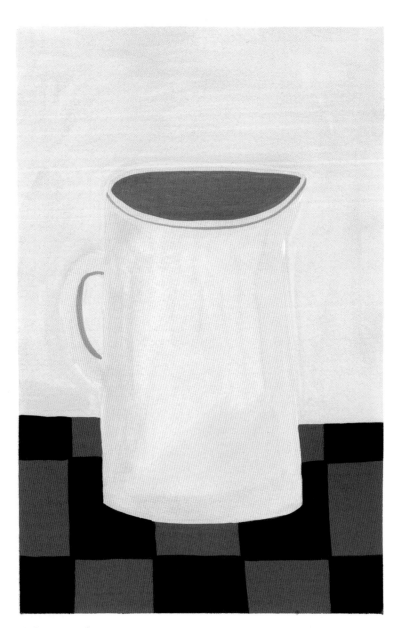

STEP 4

Using a dark blue paint, draw vertical and horizontal lines to create a checkerboard pattern on the bottom part of the background. Then fill every other square with the same dark blue to create tiles.

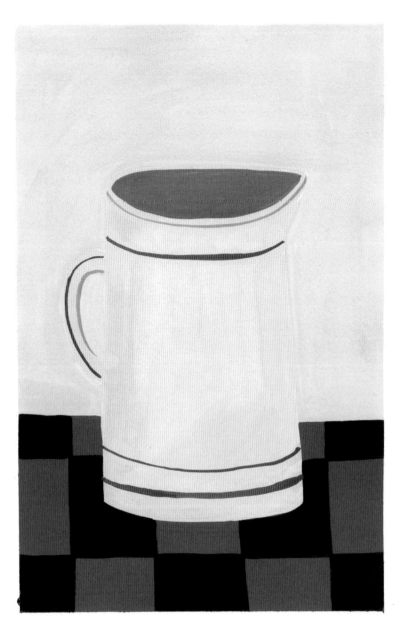

STEP 5

To finish, use a vivid orange to contrast with the blue background, and add decorative lines on the jug.

Use this pitcher to practice painting other vessels, such as pots, vases, bottles, and glasses. All have a vertical shape with a round opening on the top, which you can paint with a darker color to give depth to the object.

Play with dark or
white lines to create
contrast and reflective
effects on glass.

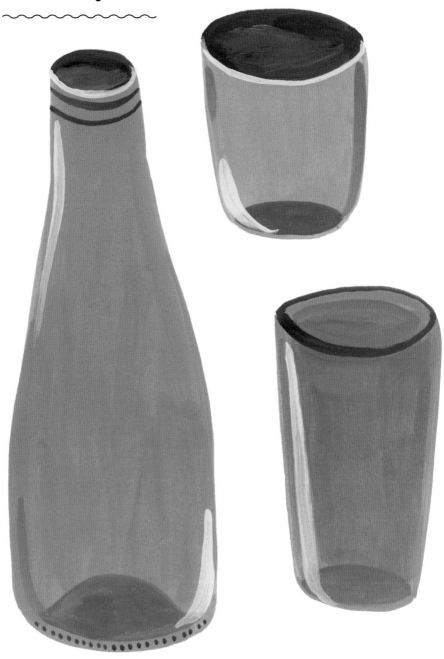

CREATE A COLLECTION

I've been working on a little project this year. Each day for 100 days, I select a familiar object in my flat and paint it. With this collection of little paintings, I try to document a moment from our family life, featuring items we use every day. This exercise is a bit of a challenge for me, as I'm not comfortable with perspective or realism, but I'm learning from each painting I make! The paintings don't have to be perfect or hyperrealistic, but the end result should look familiar to me.

Working on a series like this is a great exercise, because although you work on many separate paintings, together they create a unified whole. Consider using similar elements—such as the same size paper or a limited range of color—in all of the paintings to give them a cohesive look.

Task yourself with a challenge, such as painting a series of objects from your kitchen cupboard or the items that sit on your desk.

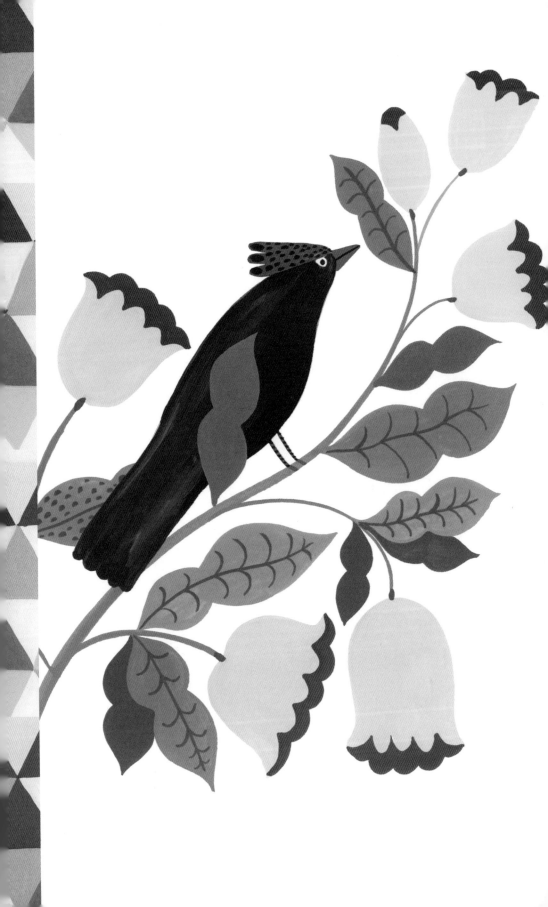

PROJECT 6
BIRD ON A BRANCH

Starting on page 44, we took a look at painting birds, those lovely, easily paintable animals. Now that you feel comfortable drawing a bird and have experimented with the colors and details of its plumage, it's time to begin paying attention to the environment around the bird.

When birds aren't flying, we can find them nesting, searching for little branches, picking up insects and crumbs from the floor, or chasing each other through the bushes. If we are lucky, we can sometimes observe birds as they rest on a branch.

You might want to take another look at the project on page 40, where we learned how to paint a flower and leaves. These skills may come in handy as we begin to play with the decor around our bird. Let's get started!

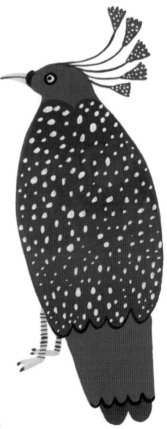

PAINTING A BIRD ON A BRANCH

Beginning with a simple bird on white paper (like the one we painted before), let's give him something on which to stand. Under his little feet, draw interlacing branches with leaves of various shapes and colorful flowers.

STEP 1

Use a bird you've already painted, like I did here, or follow the instructions starting on page 45, and paint a simple bird.

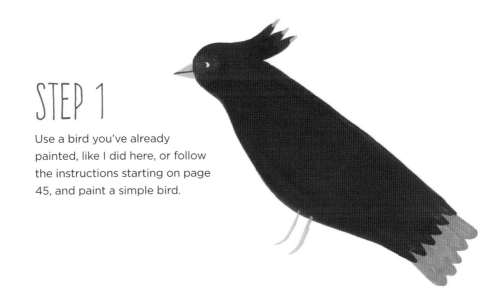

STEP 2

Paint a line for the branch. Be sure to draw a line that is a bit wavy, supple, and not too straight.

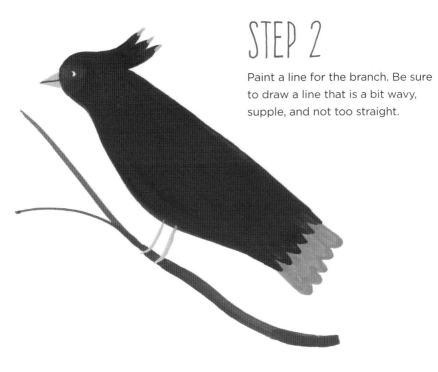

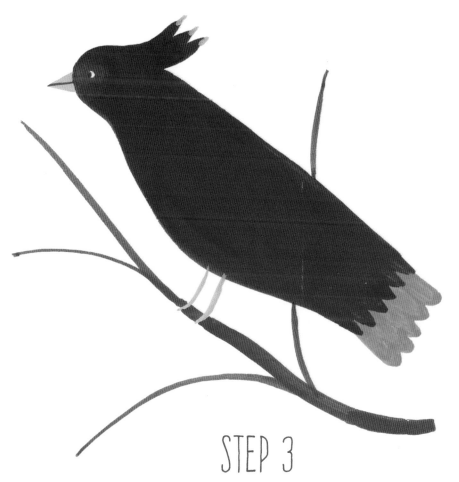

STEP 3

Add three more little branches extending from the main branch, with one behind the bird. These branches will support the leaves and the flowers.

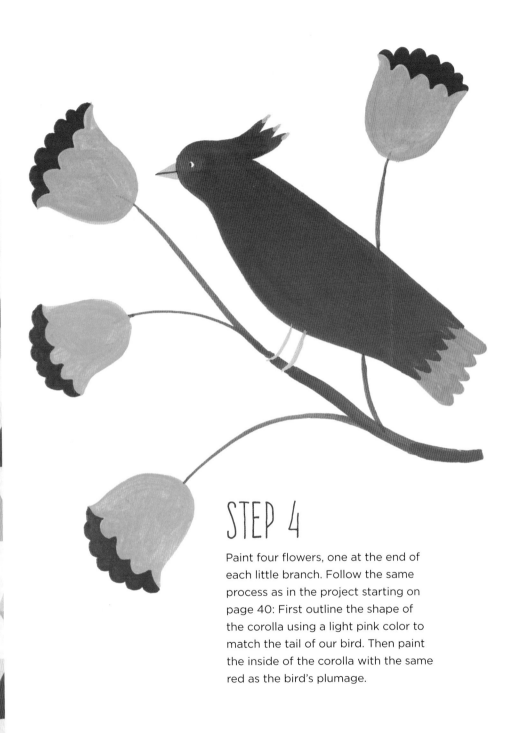

STEP 4

Paint four flowers, one at the end of each little branch. Follow the same process as in the project starting on page 40: First outline the shape of the corolla using a light pink color to match the tail of our bird. Then paint the inside of the corolla with the same red as the bird's plumage.

STEP 5

Using a green tone, paint numerous leaves, each in an oval shape with a pointy end. I make some leaves big and others small, attaching them to the branches.

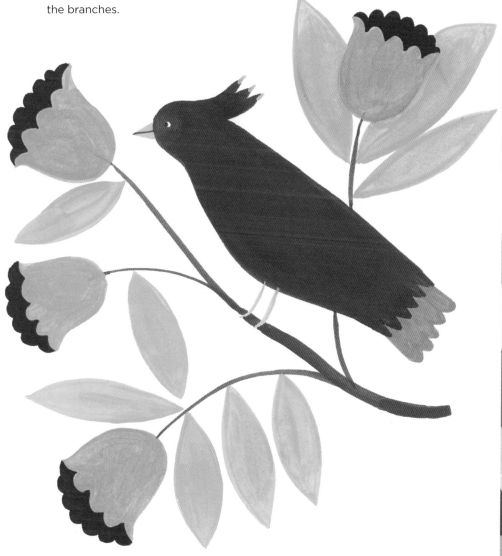

STEP 6

To finish, add more leaves under and over the bird and flowers. Then, using a darker green tone, add details to the leaves.

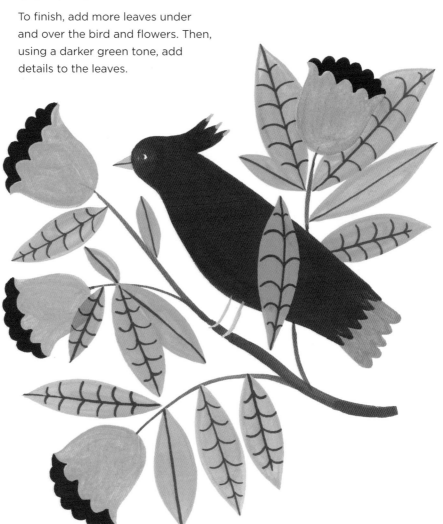

By painting some leaves over the bird, you give the impression that he is hidden inside the bush. This effect creates depth in a painting.

Consider adding more
than just one bird
on the branch—try
adding some flying
butterflies around him!

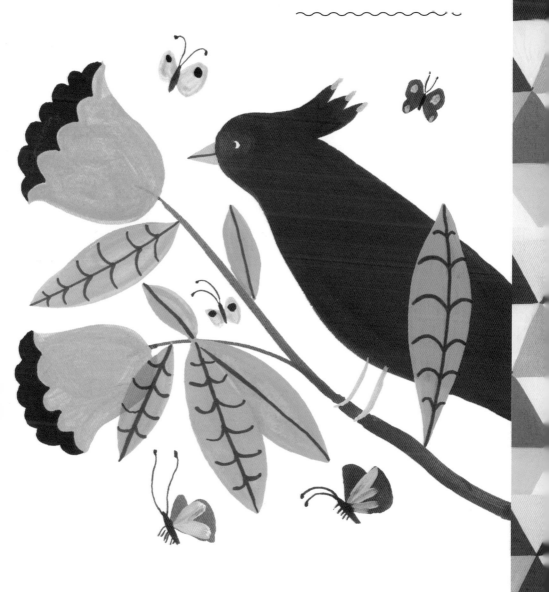

GROWING YOUR GARDEN

With this little bird plus branches, flowers, and leaves, you've got a great start for painting a garden!

Try adding other branches and more animals. Additional birds, butterflies, squirrels, and beetles would all work well in this setting. Can you think of any other animals or insects to add? Also, depending on the colors you use, you can create various types of gardens. Will it be a jungle with dark leaves and mysterious animals? An exotic garden full of bright colors and extraordinary birds? A forest or simply some plants on a balcony? Will it be at a specific time of the year, like autumn when the leaves are falling or spring when all the flowers are blooming?

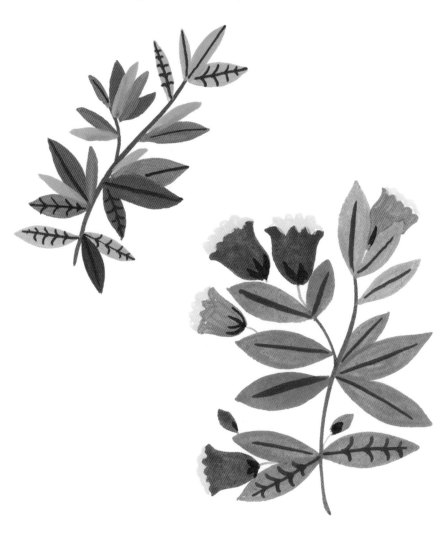

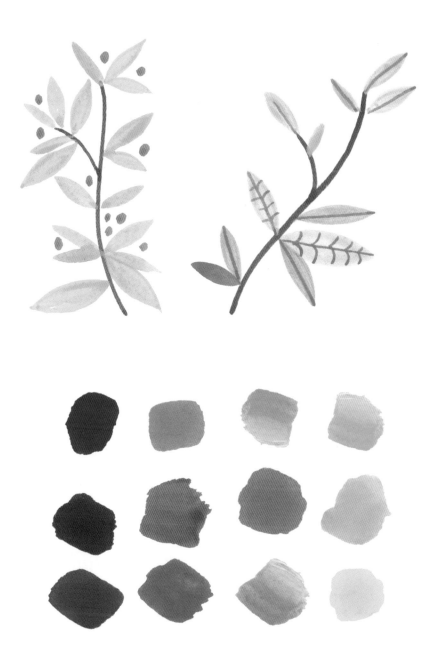

Try using different ranges of color to create a seasonal garden: orange, yellow, red, and other warm colors for autumn; gray, blue, and cooler colors in winter; soft pastels and blooming plants in spring; or plenty of bright, joyful colors to evoke summer.

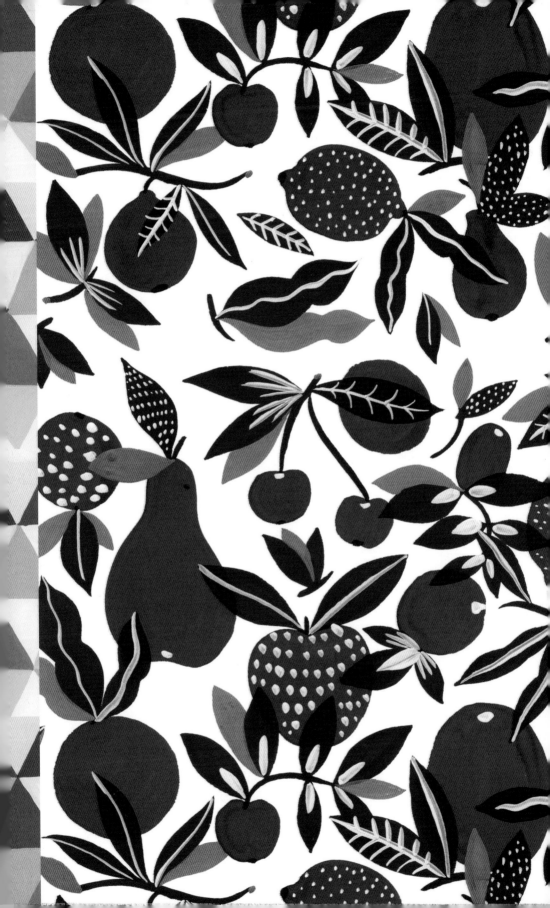

PROJECT 7
FLORAL PATTERN

When I don't work on a painting with a single subject—like a bird, a portrait, or some other object—I love to work on patterns.

Painting a pattern is a particular exercise. You have to compose your image without a central subject. Your motif has no central point of focus and can be repetitive. If you paint a pattern consisting of birds, for example, no one bird should be bigger or more prominent the others—they should all play an equal role in the overall design.

I love to paint patterns with flowers. To me, it is like painting a bouquet without a vase, not knowing where the flowers start, where they end, or where they come from. This type of painting is not abstract, but it isn't reality, either.

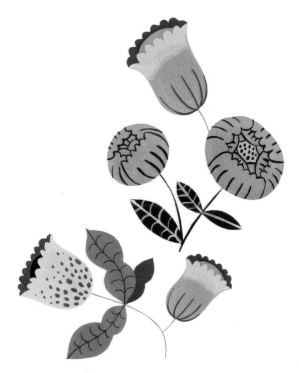

75

PAINTING A FLORAL PATTERN

For this project, we will paint a floral motif on a colored background using only three colors. Painting with only a few colors is a useful exercise, especially if you want to print your motif later, as many printing techniques (serigraphy, risography, lithography, etc.) offer a limited range of color. Let's give it a try!

STEP 1

I begin by running an even line of masking tape around the edge of my paper to protect it and create a frame. Then I paint the entire background with a light pink color and wait until the paint is dry.

STEP 2

With a vivid blue, paint four curvy lines to make the stems of the flowers. I want them to extend beyond the frame, so I overlap the masking tape with some of the stems.

STEP 3

From those main stems, add more blue lines, making them thinner than the larger curvy lines in step 2. The outline of the motif is now ready.

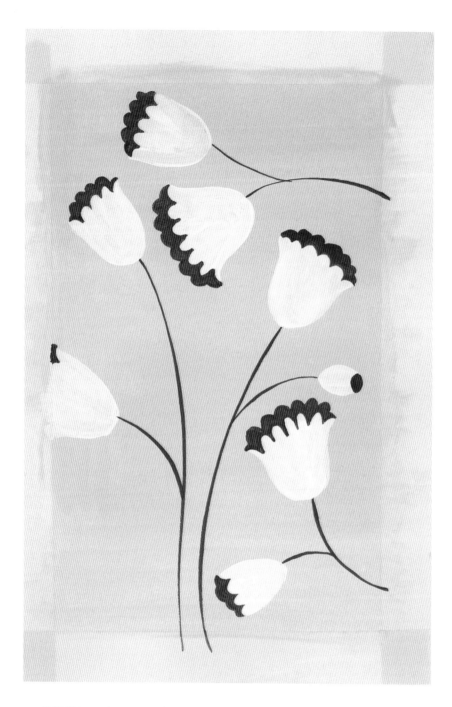

STEP 4

Paint a white flower at the tip of each blue line,
and fill the inside of the corolla with a bright
orange or red paint to create contrast.

78

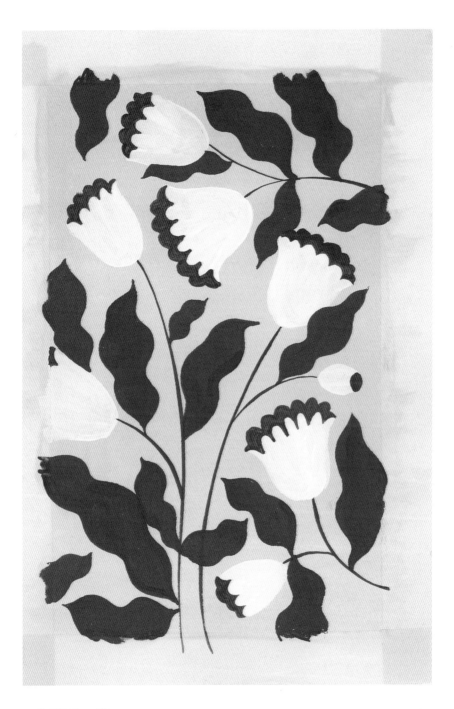

STEP 5

Paint several wavy, blue leaves
along the blue lines.

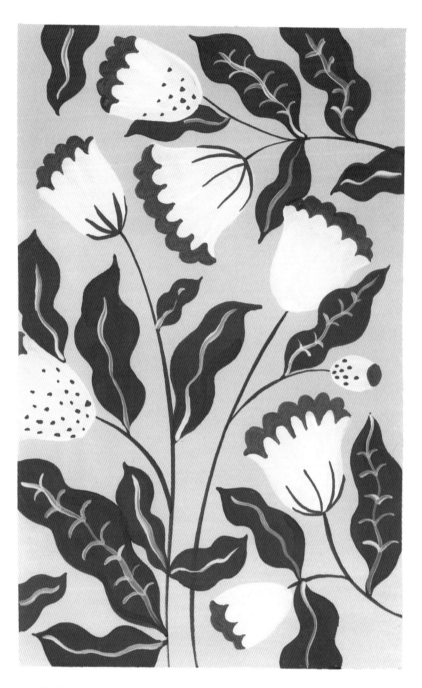

STEP 6

To finish, add white veins on the leaves and blue details on the flowers' corollas.

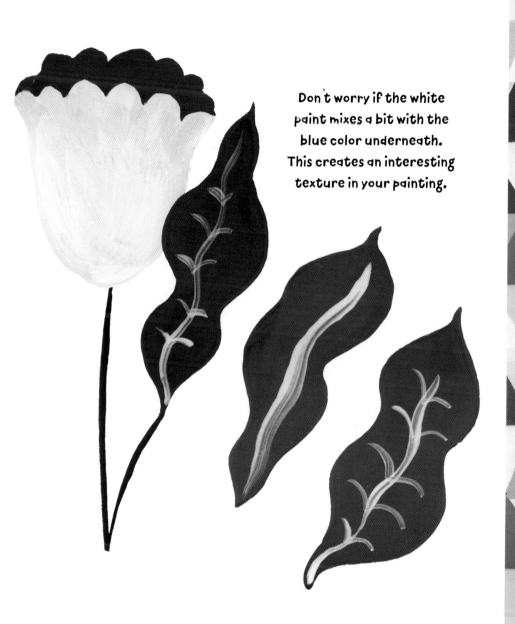

Don't worry if the white paint mixes a bit with the blue color underneath. This creates an interesting texture in your painting.

Practice using few colors and creating interesting contrasts in your art. Try using four colors, then three, and then two!

PATTERN DESIGNS FOR TEXTILE

Try using a very small painting to create a pattern, and then add to it to develop a design that feels limitless. This pattern can become a larger motif in a textile print, for example. There are two types of patterns: a "placed" design is one that has a beginning and an end, while an "all-over" design can be endlessly repeated.

I had the great opportunity to work with Arthur Arbesser, an Austrian fashion designer, on two of his collections. For each I created separate elements—birds, flowers, and leaves—which were later turned into all-over patterns printed on fabric. When arranged together, the birds, flowers, and leaves created a colorful story, where every single element became one with the rest.

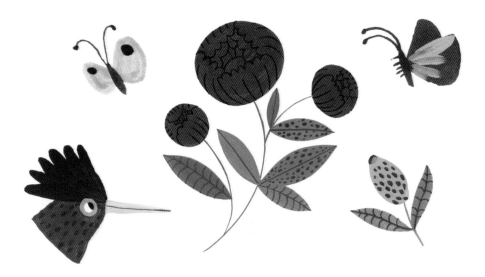

Using separate elements that you've already painted, try to mix them together to create a pattern. If you have a scanner, scan the pieces and repeat them digitally. You can also work in a more old-fashioned way and cut and glue different little paintings onto a larger piece of paper.

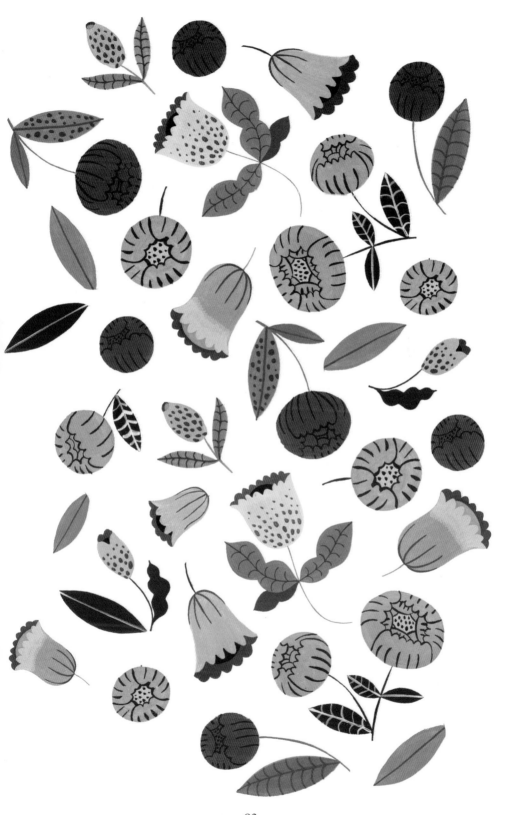

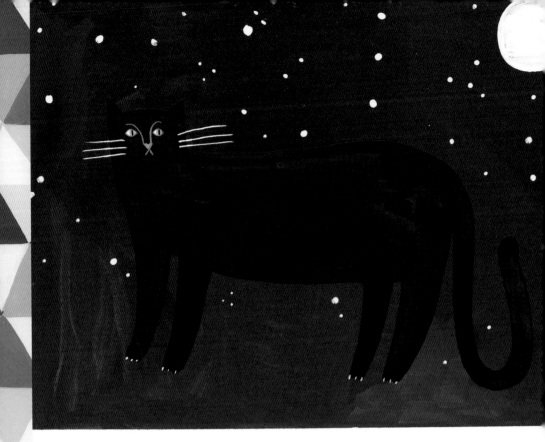

PROJECT 8
NOCTURNAL CAT

I love to paint cats, leopards, and panthers, so much so that I even painted a blue panther for my business cards. Felines make great motifs, as they can be familiar or mysterious figures. Felines work equally well as a subject for a warm and cozy interior painting or in the fierce atmosphere of a dark jungle. They offer an interesting contrast between the elegance and strength of their bodies and the coziness of their fur and purrs. Felines have beautiful eyes with a dark, vertical pupil and very long whiskers, which are fun details to paint.

When I paint a feline, I approach it like this: a body with four delicate legs, a long tail, two small ears, a short nose with the tip in the shape of a heart, round eyes, and long whiskers. If it's a small cat, the head would have to appear bigger; if it's a panther, the head should look smaller, creating the illusion that the body is bigger and more impressive.

Felines are usually night creatures, so our next subject is painting a cat in the dark. Representing a subject makes you think more carefully about the light you bring into the painting instead of the darkness all around the subject. In this painting, we will use mainly dark colors, adding a few very bright details to bring contrast and life to our scene.

84

PAINTING A CAT AT NIGHT

Let's paint our cat like a shadowy silhouette on a dark blue background. The moon, stars, and details on the cat will be the highlights in the painting.

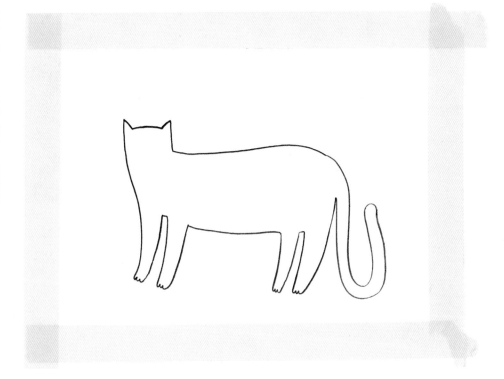

STEP 1

Start with the shape of the cat painted from the side view—a body standing on four legs. On the left side of the body, paint the head with one pointy ear on each side. On the right side, draw a long tail that extends down to the ground.

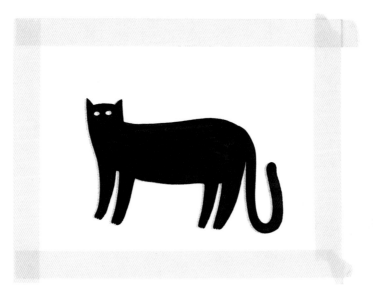

STEP 2

Fill the entire shape with black paint, leaving only two little circles for the eyes. Allow the paint to dry completely.

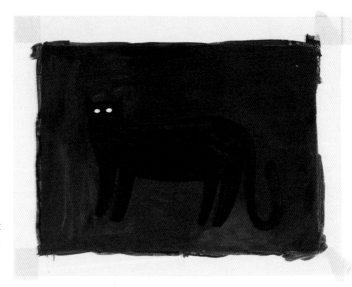

STEP 3

Paint the background around the cat dark blue, but not too dark; the cat should contrast with the night sky.

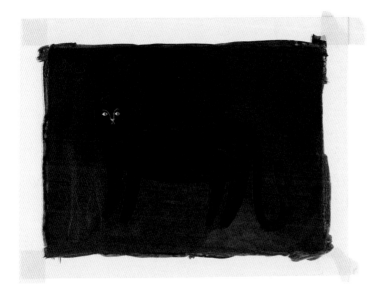

STEP 4

Then add details to the cat. Use a light green color for his eyes. When the green paint is completely dry, paint one vertical black line in the center of each eye to create the pupils. Paint his nose, placing two thin, gray lines that begin between his eyes with a small light pink heart shape in the middle.

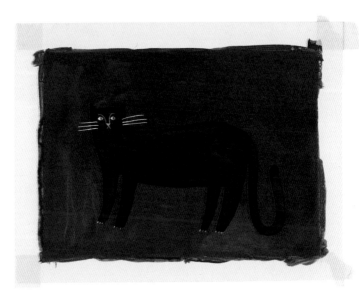

STEP 5

Using white paint, draw the cat's whiskers and claws.

Pay attention to the nuances of dark paint in your work, and try to maintain a good contrast between the main subject, the background, and the other elements.

STEP 6

Use the same white paint to create the
moon and stars in the sky.

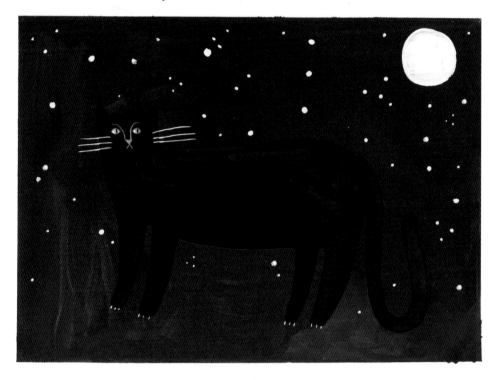

When you look at the sky at night, you will see that the
stars are not evenly distributed. Try to paint some
stars grouped as imaginary constellations. Draw some as
very tiny pinpoints, and others bigger as full circles.

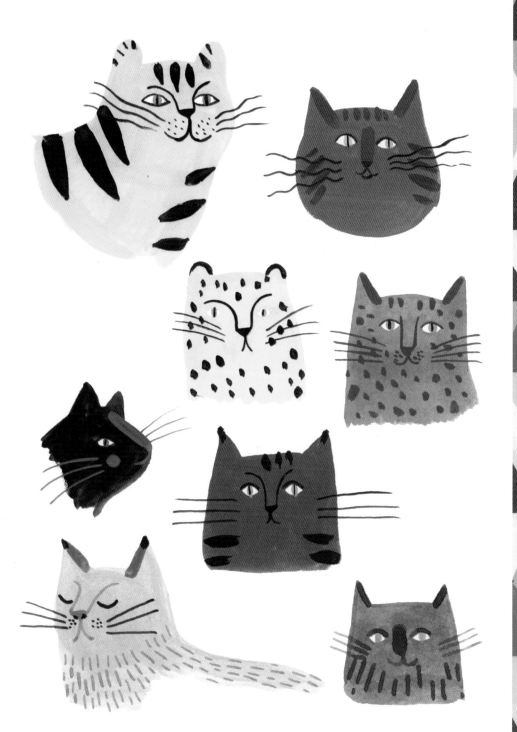

You can practice creating different motifs and colors for your
cats, big or small. Have fun painting dotted and striped fur
and adding details like long whiskers and round markings.

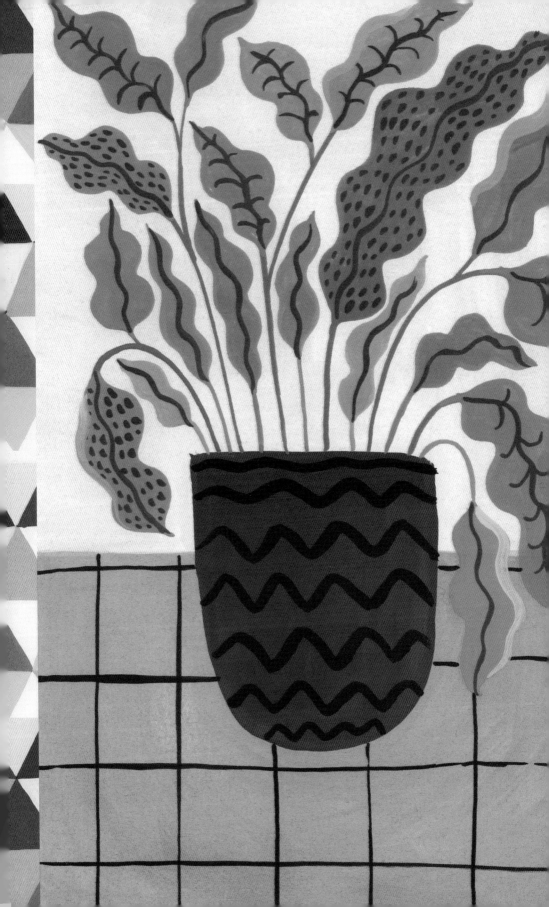

PROJECT 9
POTTED PLANTS

You can find great inspiration in home and interior decor. I am sitting now in my living room, which is also my office and studio. If I take a look around me, I see the colors of my sofa; the pattern on the rug; the multicolored stripes of a blanket on a chair; a light pink vase on my fireplace, filled with white lilies; and other familiar objects that I love—lamps, mirrors, books, and so on. They are a great source of ideas for patterns and combinations of colors.

You can also often find nature in the house, and that is the subject that we will paint now. Let's take my favorite potted plant. We call her Marcel, and she has been a friendly presence in this room for years. Marcel has very wide, wavy leaves in a beautiful vivid green with darker lines that seem to have been painted on.

Let's paint this potted plant on a colorful floor and background and see how we can play with details and patterns to create a little series of paintings.

91

PAINTING A PLANT IN A POT

On a two-colored background, let's paint a plant in a colorful pot and add interesting details on the leaves, the pot, and the floor.

STEP 1

Start by painting the pot. Paint an oval shape, making it thinner on the top and larger at the base. Fill in the shape with a bright yellow color.

STEP 2

Next paint around the vase. First paint the
floor in a vivid pink paint, and then make
the background a very light blue tone.

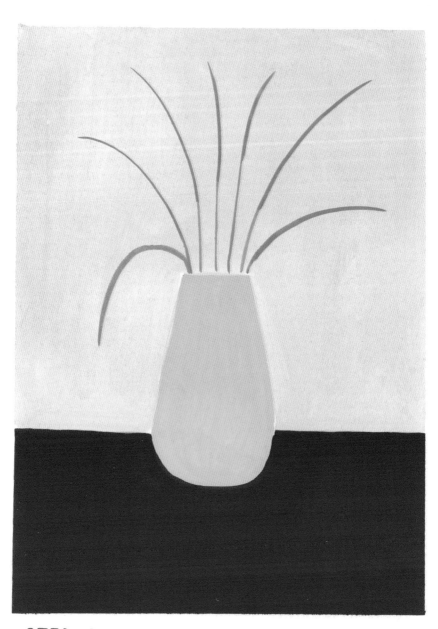

STEP 3

Wait until the paint is dry. Then, using
a vivid green tone, paint thin stems,
starting from the top of the pot and
fanning out across the blue background.

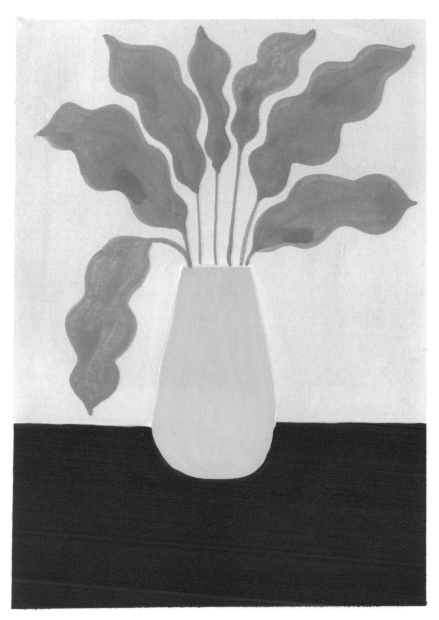

STEP 4

Paint a wide and wavy-shaped
leaf on each branch using the
same green color.

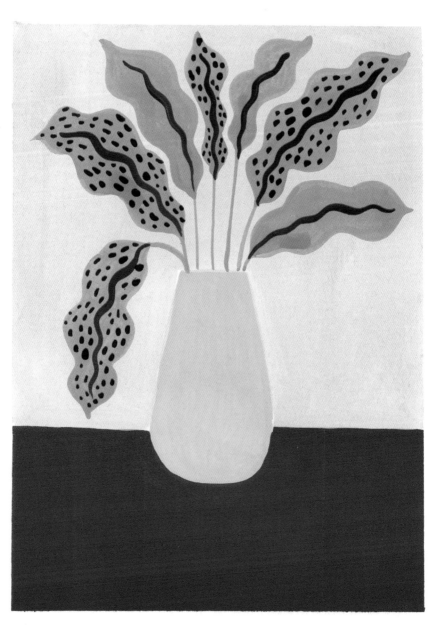

STEP 5

Using a darker green tone, add details on the leaves with wavy lines and tiny dots.

STEP 6

Then paint a pattern on the pot using an orange color that contrasts with the yellow. To finish, paint a pattern of stripes on the floor using a dark burgundy paint.

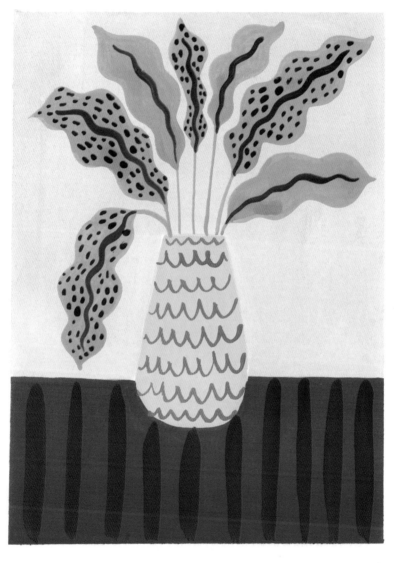

Play with a variety of patterns to add details on the floor. Pay attention to floor patterns you see in your everyday life, and keep in mind the motifs you see. Crossing lines and contrasting colors of floor tiles, lines on a parquet floor, or patterns on rugs and carpets can all serve as inspiration in your paintings.

PAINTING A SERIES OF POTTED PLANTS

Beginning with our first painting of Marcel the potted plant, you can now create a series of paintings of indoor plants. Repeat the steps you just followed, but each time change the colors and the patterns in your paintings. Try a very vivid background with a light floor. Match the color of the pot with the color of the ground, or create a flashy contrast between the two. Will your plant be a delicate orchid or a tousled palm? Add flowers or fruits to the plant. Play with a variety of patterns on the pot, the leaves, and on the ground; we tried crossed lines, stripes, wavy lines, and dots—which other patterns can you imagine? Put your series of paintings together, and see how mixed colors and patterns create a playful set of images.

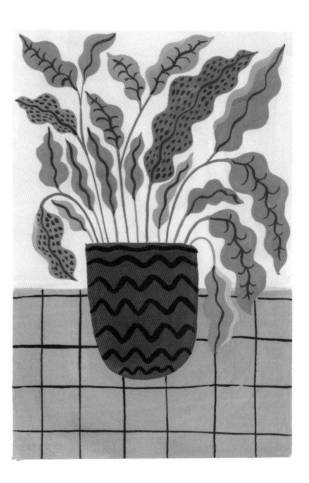

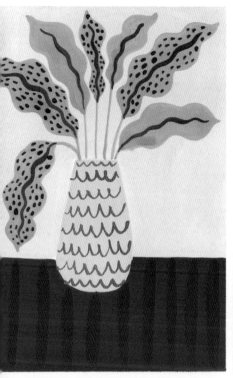
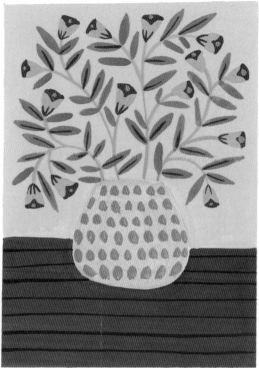
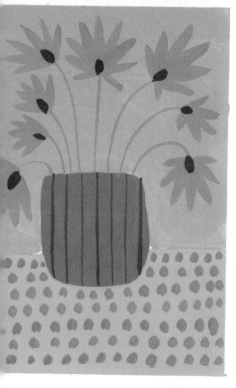
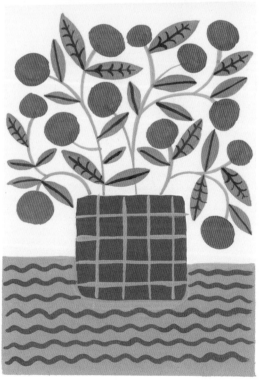

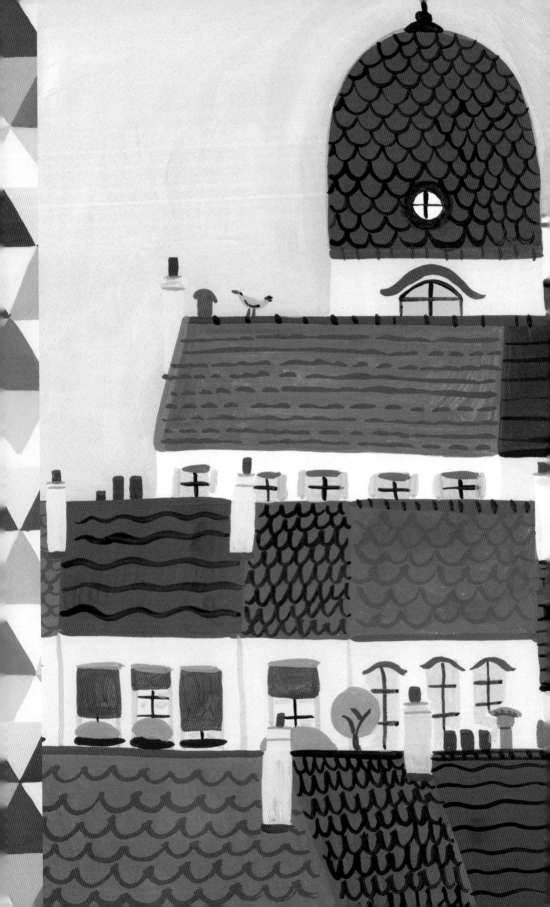

PROJECT 10
CITY ROOFTOPS

The desk where I like to paint is located near a window with a view overlooking a courtyard. From this vantage point, I can see my neighbors' windows, which are covered with curtains of various colors and patterns; little balconies full of flowers and plants; and sometimes, I even have a glimpse inside the flats. I can see the details of the rooftops, the rain gutters, and the chimneys of various sizes.

Here in Paris, the roofs have an interesting pattern of crossing lines and scale patterns in a beautiful range of blues and grays. The walls are made of a light beige stone and the chimneys are bright red brick.

Inspired by those blue, beige, and orange colors, let's paint a view from the window, looking out on the rooftops of the city.

PAINTING ROOFTOPS

On a light blue background that represents the sky, let's paint three rows of rooftops and multiple little windows. Then we will add details and patterns.

STEP 1

Start by painting a two-color background using light blue on the upper part for the sky and a light beige below for the walls of the buildings. Let the paint dry.

STEP 2

Using a range of dark blue colors, paint three rows of roofs using rectangular shapes of various sizes. Let the painting dry before moving on to step 3.

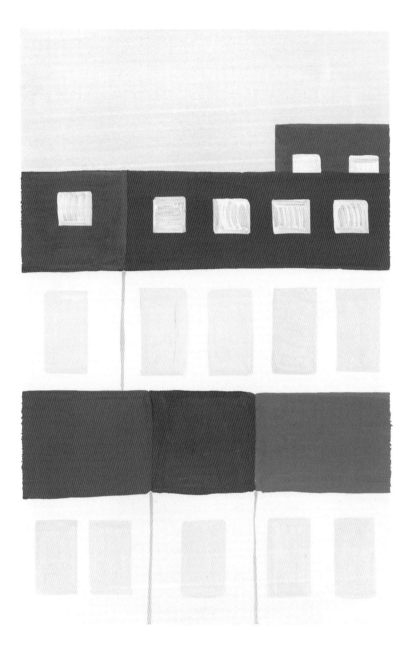

STEP 3

Using a light pink tone, paint three thin, vertical lines to separate the houses. Then, with a light blue color, paint numerous rectangular shapes to form the windows, with bigger windows below and smaller ones on the roofs. Let the paint dry completely.

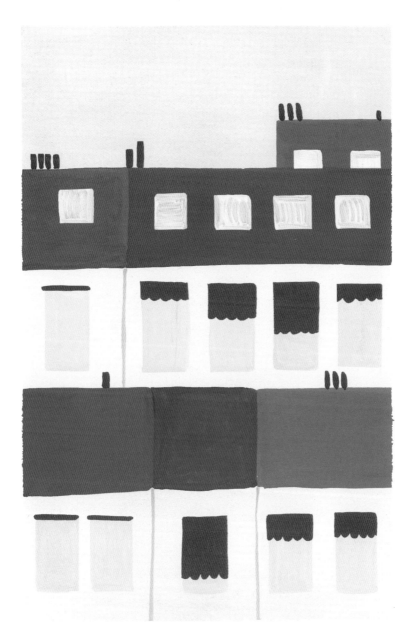

STEP 4

Use a vivid orange or red color to add little blinds on the windows. Starting at the top of each window, paint a rectangular shape, and then create a scalloped edge along the bottom. Some blinds are open, while others are pulled down. Next, use the same color to paint little chimneys on top of each roof.

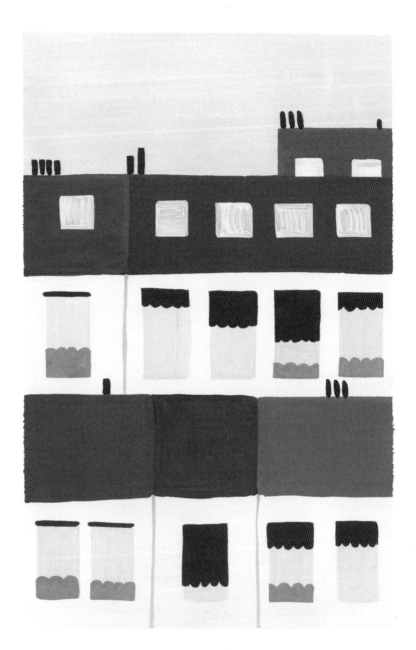

STEP 5

Using a bright green tone, paint plants
on some of the windowsills.

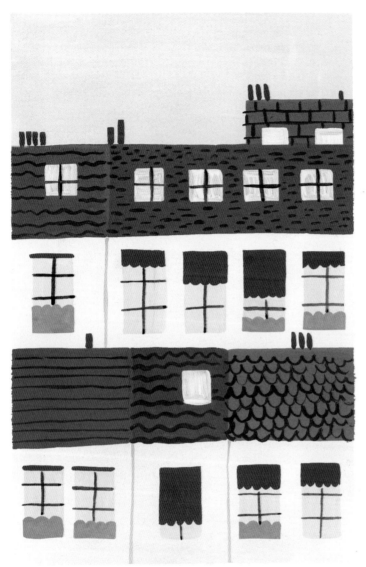

STEP 6

Finish the painting by using a dark blue tone to add patterns and details on the roofs. Draw straight lines, wavy lines, and fish-scale patterns. Finally, paint perpendicular lines across each window to separate the panes of glass.

Add life and characters to your view of the city—paint a bird standing on a chimney, a cat walking on a rooftop, or a face looking out a window.

LOOKING THROUGH THE WINDOWS

When painting a view across the rooftops of the city, take a closer look at the windows, and add life and details to each of them. These details can take many forms, including a partial view of the inside of an apartment with furniture, people watering plants on a balcony, a dog looking out a window, a bird in a cage on the balcony, and so on.

Start by painting rectangular shapes for the window. When the paint is dry, paint two perpendicular lines over the windows to represent the individual panes. This will add depth to your painting and the impression that you're really looking through the glass.

Take some time to study the buildings, rooftops, and/ or skyline of your city, making note of the colors, patterns, and distinctive details of the building materials. Incorporate these details into your work.

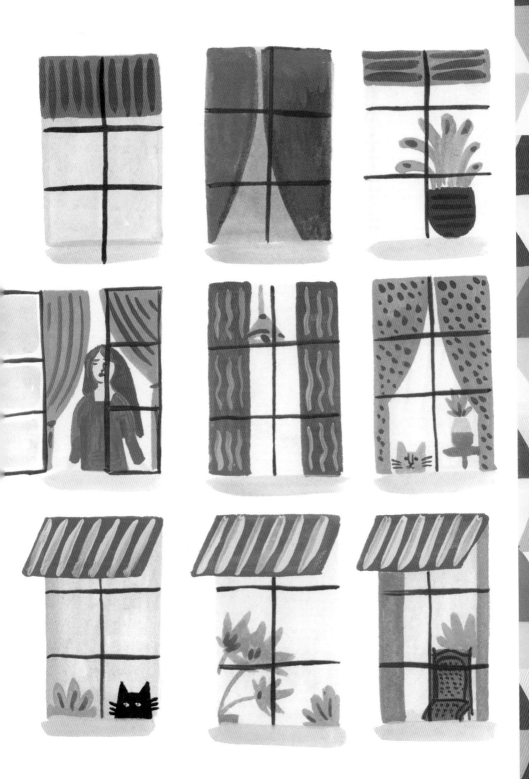

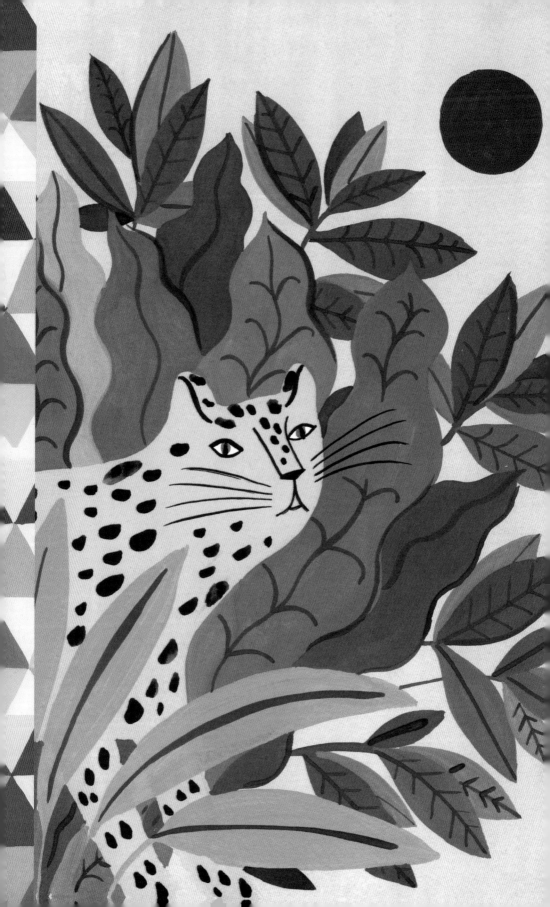

PROJECT 11
HIDDEN ANIMALS

As a child, I was very inspired by the colorful and mysterious paintings of Henri Rousseau. This French artist spent his life painting exotic jungles, wild animals, and mysterious countries—despite never having actually left France. Instead, he used his vivid and beautiful imagination. In his jungle paintings, you can find animals hiding between the plants. Snakes, wild cats, and monkeys disappear in the shadows cast by wide leaves and colorful flowers. Rousseau's paintings are done in a naïve style without any sense of perspective. On the contrary, each scene seems to be built much like a stage set—layers of decor between which characters pass.

In this project, we will paint a cat hiding between plants and foliage.

By painting leaves over and behind the main subject, you can create a playful hide-and-seek effect.

PAINTING A CAT IN A GARDEN

Let's begin by painting a cat as you learned to do starting on page 85. Then we will add plants in front of and behind him to give the impression that he is hiding in a garden.

STEP 1

Start by painting a cat sitting on its hind legs. Let it dry before adding details. It has gray fur with darker gray stripes, green eyes, and pointy whiskers.

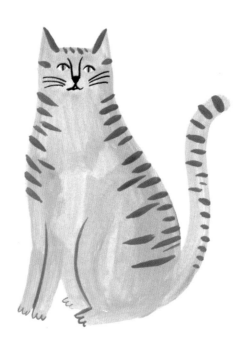

STEP 2

Next paint the stems of the plants in front of and over the cat. Using a bright green tone, paint several lines beginning from the ground and extending up almost to the cat's nose. Then add red circles at the end of the lines on the right to create the round shapes of flowers.

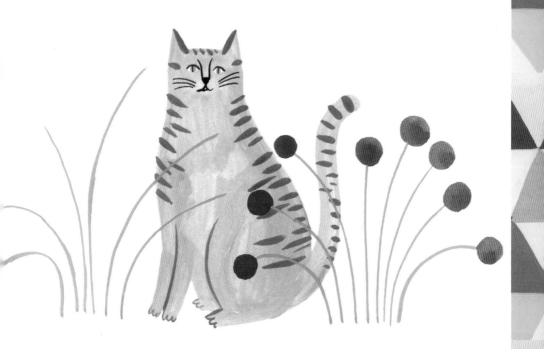

STEP 3

Using a range of bright green tones, paint leaves on the stems. Draw large and wavy-shaped leaves on the left and many small and pointy leaves on the right.

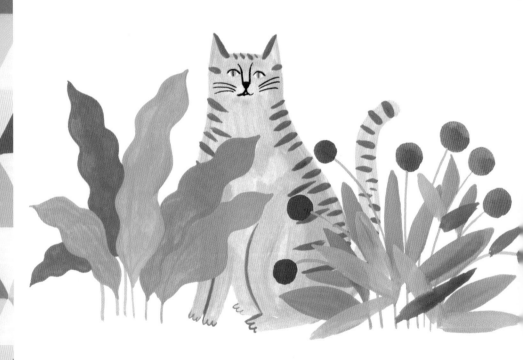

STEP 4

Paint a plant behind the cat using
a dark green tone to create depth.
The plant has simple wide leaves
with a wavy shape.

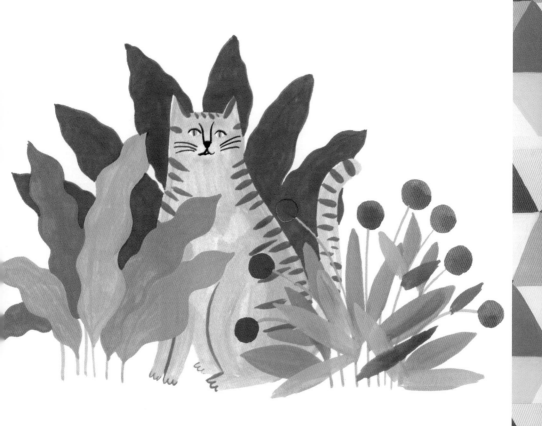

115

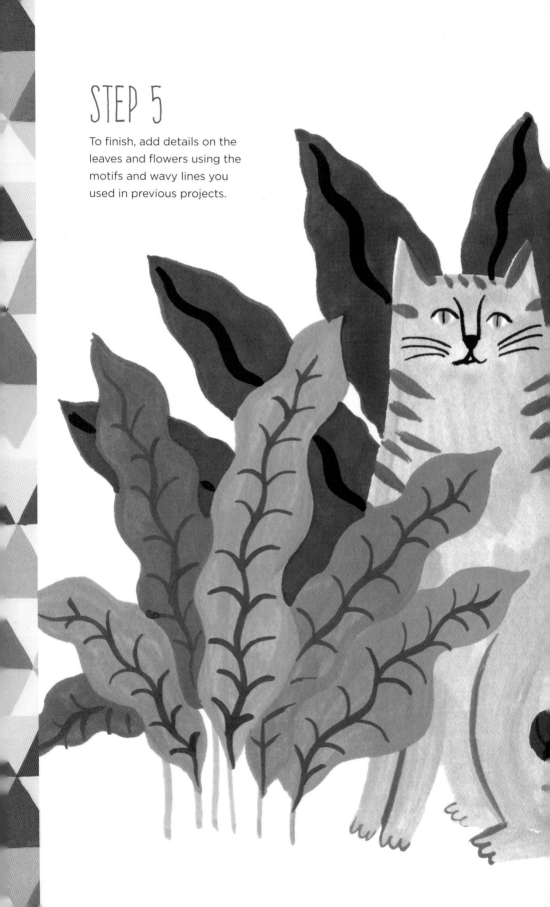

STEP 5

To finish, add details on the
leaves and flowers using the
motifs and wavy lines you
used in previous projects.

GARDEN FULL OF HIDDEN CREATURES

The painting of a cat hiding between three plants can be expanded to create a larger landscape of a vast garden or an exotic jungle full of animals.

Begin by painting a one-tone background, such as blue for the sky or dark green to represent the shadow of a forest. When the paint is completely dry, you can add animals, plants, and flowers over that background. Wait until that second layer has dried, and add more flora and fauna. You can finish by painting details on the leaves, flowers, and animals, such as spotted or striped coats, feathers, and so on.

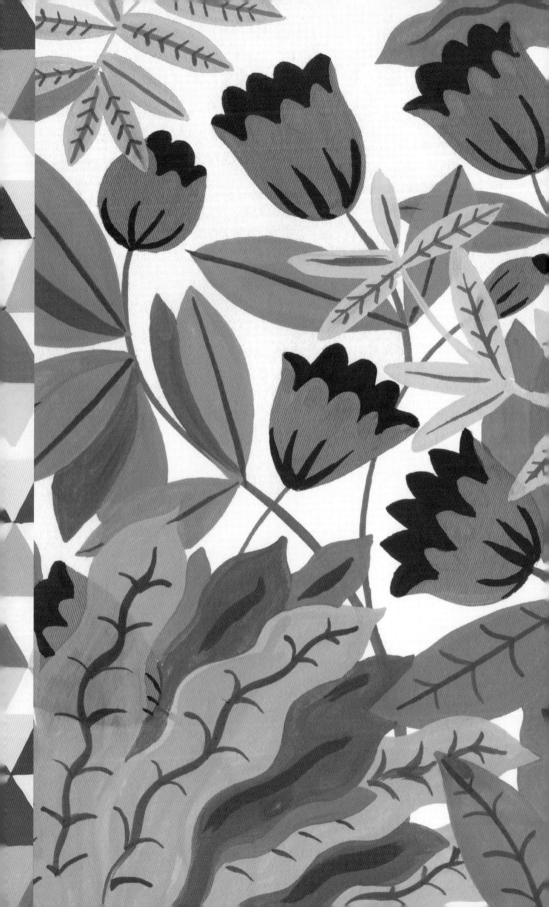

PROJECT 12
GARDEN ON A BALCONY

I grew up in the country in a house with a huge wild garden surrounded by forests and fields. My parents loved to garden and grew vegetables, roses, and fruit trees. Although I learned a lot about gardening as a child, I've unfortunately never had a green thumb!

Now that I live in Paris, I still like to see nature around me. For my 20th birthday, my family gave me some bushes and little trees so that I could have my own miniature garden on my balcony. I kept and cherished those plants until I moved into a new place without a balcony, and then the plants went back to the countryside.

I used my memories of that little garden to paint this piece. Let's learn how to paint a little urban garden that's small enough to fit onto a balcony, but still joyful and leafy.

Try painting different types of gardens. Experiment with painting a very tidy rose garden or an exuberant, exotic jungle.

PAINTING A SMALL GARDEN

Let's begin by painting potted plants as we did on page 92, but this time we'll do several. You'll then paint the outlines of a wrought-iron balcony in front of the pots.

STEP 1

Start by painting five pots in different shapes using a range of light orange tones. Some pots should appear closer to the viewer; paint them in front of and over the others.

STEP 2

Under the orange pots, paint a light gray half-circle shape to represent the ground.

120

STEP 3

Then paint the two plants that are farthest away. On the left, paint a cactus with taller, rounded branches. On the right, paint a large bush with pointy leaves in a fan shape.

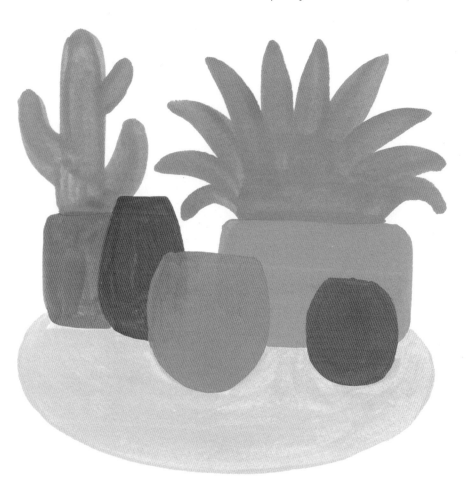

STEP 4

Using darker green tones, paint three other plant shapes in the foreground: a little round topiary tree on the left; a small, rounded cactus in the center; and a plant made up of a bunch of wavy-shaped leaves on the right.

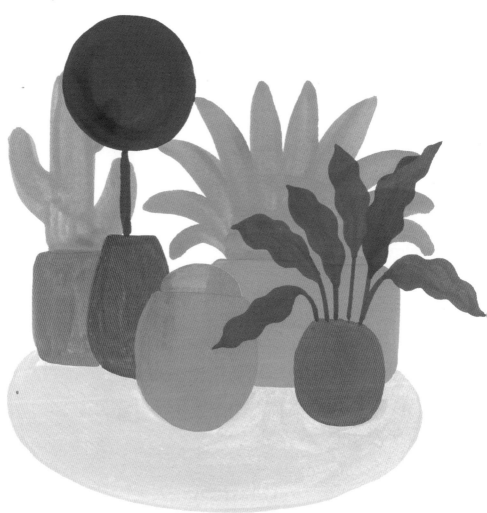

STEP 5

Once the paint is completely dry, add details on the leaves of the plants. Paint several rows of scalloped designs over the little round tree, wavy lines on the leaves, and quills on the two cacti.

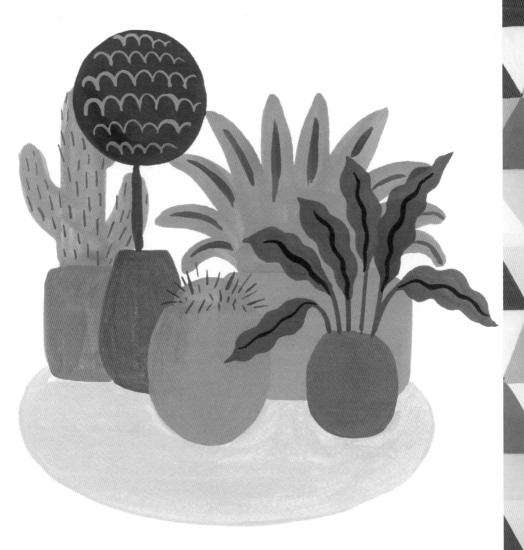

STEP 6

To finish, use a black tone to paint the outline of an iron balcony in front of the garden. I start with a rectangular shape and add wavy lines and circular details.

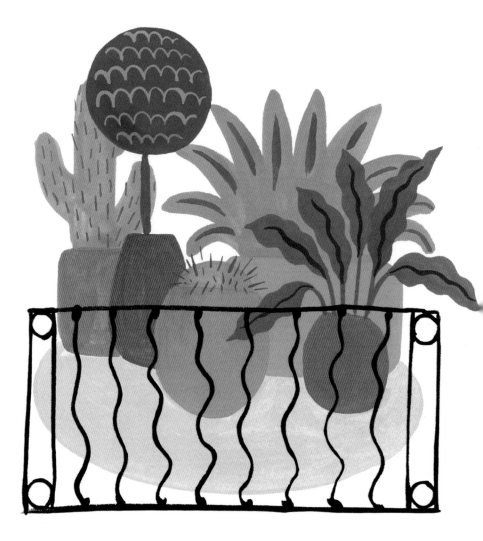

Painting a black outline over your garden can add an element of decor that contrasts with the colors of your plants. If you are unsure and do not want to risk messing up your painting, you can paint the black outline on the side, scan it, and add a digital version of the balcony to your painting later.

PAINTING A SERIES OF LITTLE GARDENS IN GREENHOUSES

In this project, you learned how to add an element of decor to the garden, such as the outline of a balcony. You can paint balconies of various shapes, but also try creating a greenhouse or a winter garden. Try painting a series of little gardens on a white background. Each can be different from the other—try a rose or vegetable garden, a bright spring garden full of blooming flowers, or a gray and blue winter garden. Then, over each garden, paint a variety of greenhouses in different shapes and sizes, using the same black outline you used for the balcony in this project. If you paint the greenhouse a bit bigger than the garden, leaving space around the top of the bushes and leaves, you will find that the greenhouse doesn't confine the nature; it frames it perfectly.

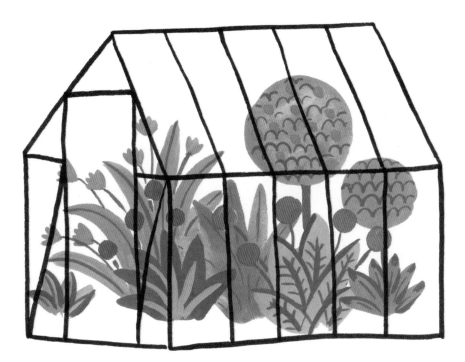

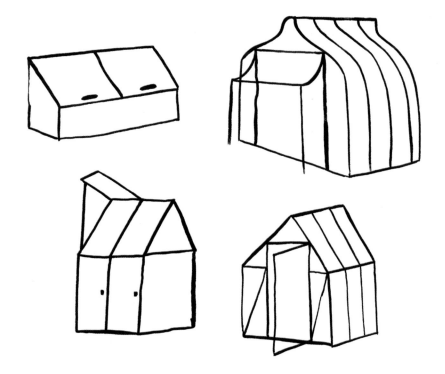

By using just an outline, you give the impression
of transparency, creating the illusion that
the viewer is looking through the glass.

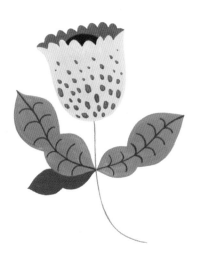

INSPIRATION

When I first started as an illustrator, I found it difficult to look at another artists' work, as it seemed I couldn't be inspired by someone without starting to copy that artist. But, with time, I learned a lot from others. Don't be afraid to mimic or draw a strong sense of inspiration from another artist's style or technique when you are first starting out. Imitation is one way to learn. What is important is to be clear about what comes from others and to develop your own sense of style. If you put a lot of personal history and inspiration into your work, it will be yours and yours only. If you show your work online, remember it is very important to always credit the artist or illustrator who inspired your work.

WEBSITES AND BLOGS

Here's a list of some of my favorite websites and blogs about illustration, art, and graphic design.

https://ballpitmag.com
This site features works by and interviews with illustrators from all around the world.

https://www.flowmagazine.com
A beautiful magazine that's sure to inspire those who love paper and illustration.

http://www.womenwhodraw.com
An open directory of female illustrators.

http://www.brwnpaperbag.com
A blog "celebrating beautiful + clever illustration."

https://www.itsnicethat.com
Turn here for a daily dose of inspiration.

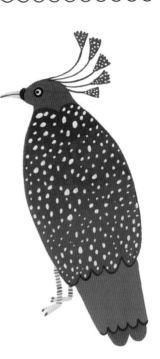

ABOUT THE AUTHOR

Agathe Singer was born in Normandy, on the northern coast of France, and left for Paris when she was 17 to study art and graphic design. After graduating in 2008, she worked as a graphic designer at an advertising agency until 2013, when she left to become a full-time freelance illustrator. Ever since, she has filled her life with paints, colors, and joyful projects.

Her studio is set in her Parisian apartment, which she shares with her artist husband and their young daughter. Her work is reminiscent of her childhood dream garden and explores a universe of colorful and naïve fauna and flora, with special attention to birds and flowers. Her clients include the Fragonard Parfumeur, the Galeries Lafayette, and the Grand Paris region. She also collaborated with Austrian fashion designer Arthur Arbesser for two collections. Les Petits Collectionneurs, a Parisian gallery that curates art for kids, edited her series "Jardin."

"I used to spend hours out in the garden and the fields with my brother and sister, building wooden huts, picking leaves for our terrariums, watching birds, climbing trees, inventing stories, and riding our pony on the beach... It was a joyful time in nature, and those precious memories nourish my work. In my painting, I'm always trying to go back to this feeling of childhood, where the world and the nature is full of joy but also strangeness."—Agathe Singer